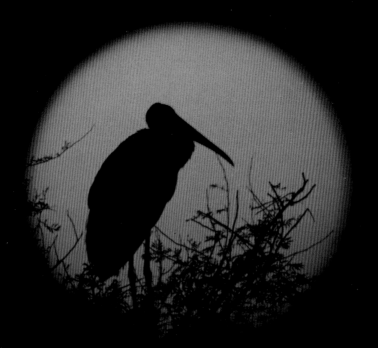

BIRDS OF
BHARATPUR

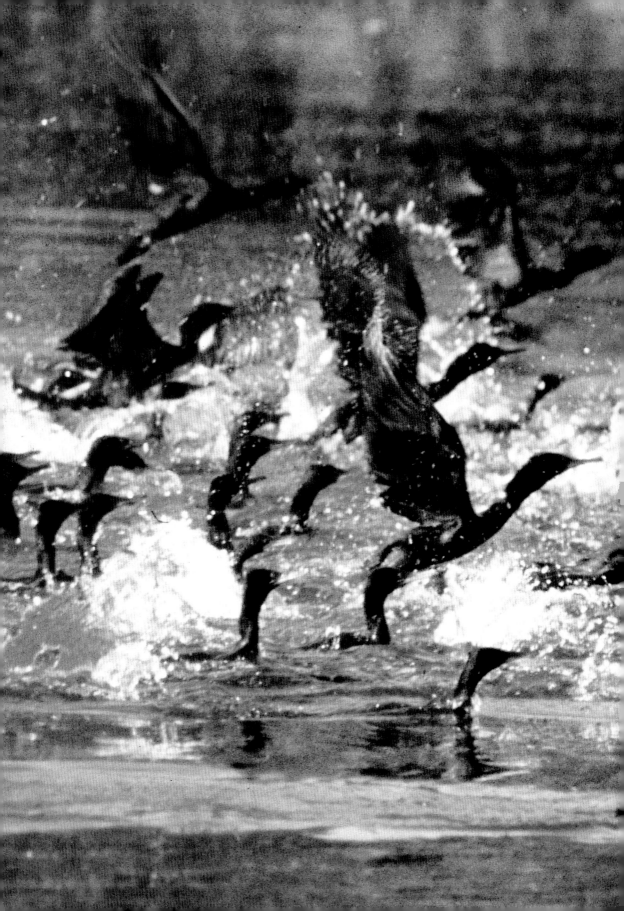

BIRDS OF BHARATPUR

Prakash Books

Text : RAJPAL SINGH
Photographs : DAULAT SINGH SHAKTAWAT
AND RAJPAL SINGH

C O N T

- 8. A Natural Heritage
- 16. The Magnificent Wetland
- 26. A Favourite Duck Shooting Spot
- 32. A Heaven for Bird Watchers
- 38. Paradise for Breeding Birds
- 52. Floating Nests
- 56. Breeding Ducks

First Published in 2005 by Prakash Book India (P) Ltd.
1, Ansari Road, Darya Ganj, New Delhi – 110 002, India.
Phone: 91-11-23243050. Fax: 23246975
Email: sales@prakashbooks.com
Website: www.prakashbooks.com
Editor: Madhu Madhavi Singh
Copyright © 2005 Prakash Books India (P) Ltd.

Design YOGESH SURAKSAH DESIGN STUDIO
www.ysdesignstudio.com

All rights reserved. No part of this publication may be reproduced, stored in a retrieval system or transmitted in any form or by any means, electronic, mechanical, photocopying, recording or otherwise without the written permission of the publisher.

Printed and bound in Gopsons Papers Ltd., Noida 201 301

ISBN No: 81-7234-051-6

Acknowledgements

The officers and staff at Keoladeo were extremely helpful in providing essential information about the Park. I am indebted to the Late. Mr Penny Singh, Mr R.G. Soni, Mr A.S. Brar, Ms Shruti Sharma, all persons incharge of the Park, for their co-operation. Sunayan Sharma, Research Officer at Keoladeo, deserves a special mention, as does Mr. Bholu Abrar Khan of the Forest Department who was always a great help. I had the additional advantage of the field knowledge o Park personel such as Sohan Lal, Shrichand and Dharam Singh. Daulat Singh Shaktawat not only kept me company through some of my most exciting encounters but also made available some of his splendid pictures.

ENTS

60. The Cranes

69. The Colourful Waterfowl

76. Lords of the Sky

88. Summer Nesters

96. Kingfishers

100. Mammals and Reptiles

110. The Fragile Ecosystem

120. Checklist of Birds

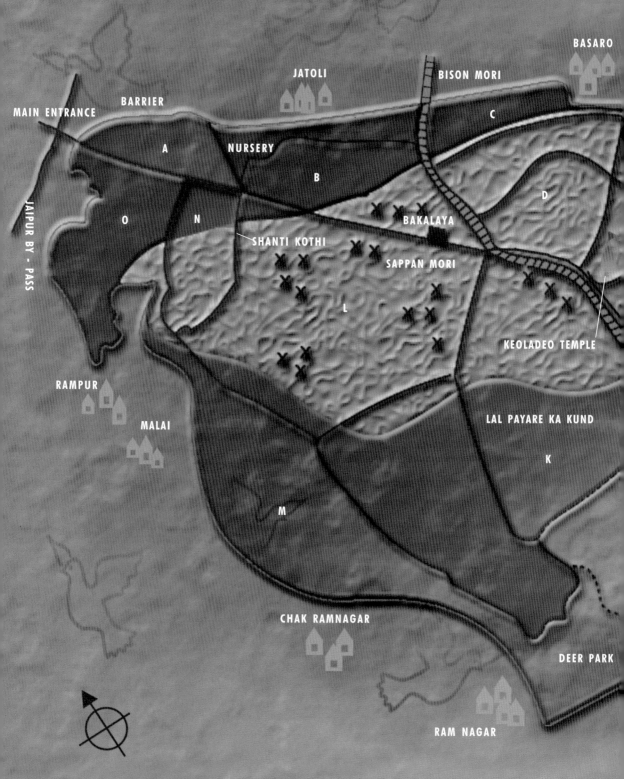

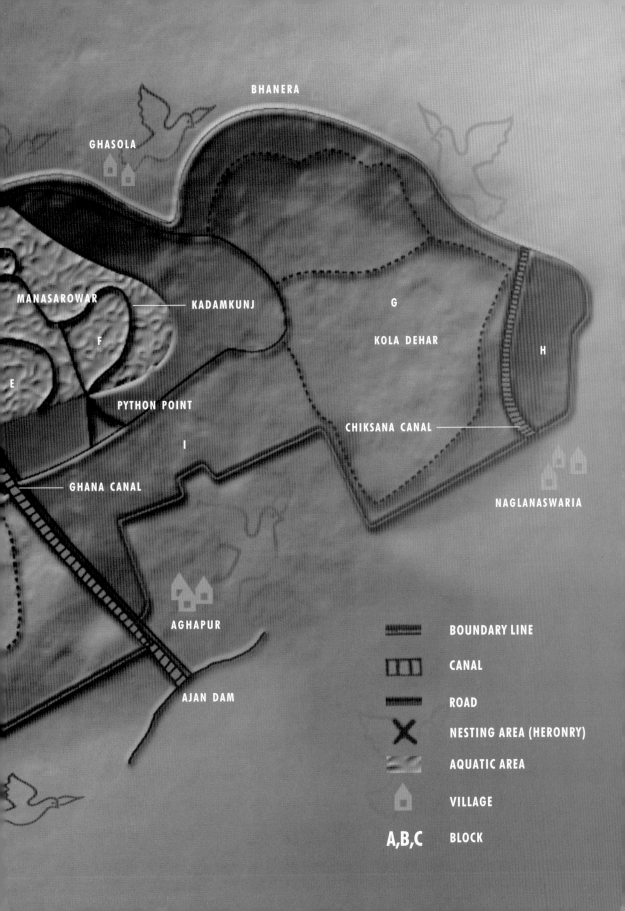

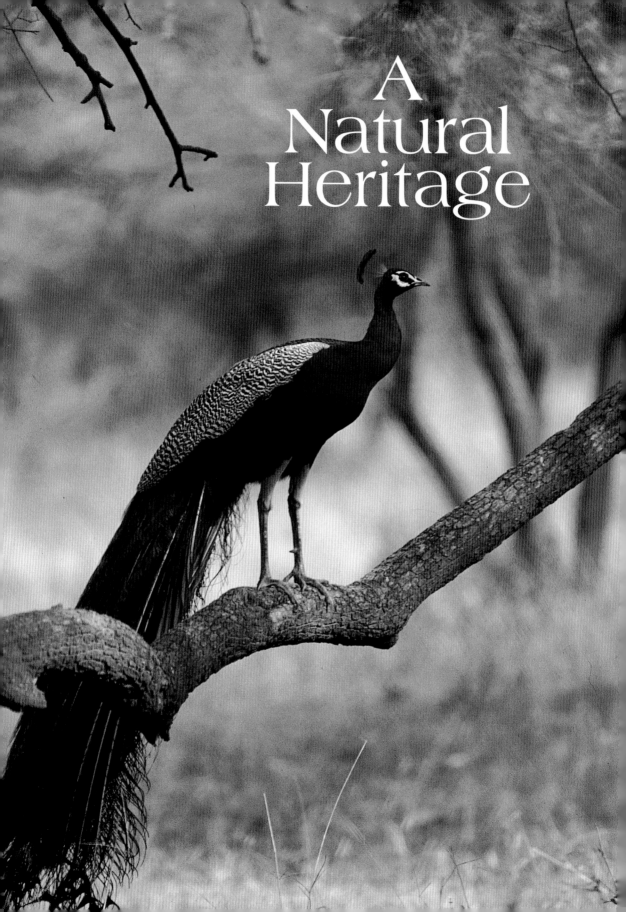

A Natural Heritage

Keoladeo National Park, Bharatpur, or Ghana as it is locally known, is a shallow, saucer-like lake fed by rainwater. During the monsoon (mid-June to September), the entire area, barring some high ground, is covered with water. A system of dykes and sluice gates helps spread this rainwater over a large area and also holds it for a longer period. But water in this extended area usually subsides within a month, leaving behind a more stable wetland spread over 8.5sq. km. Even within this area, the lakes are ephemeral and usually dry up during the summer months. This, combined with the bright tropical sun, silt and changing moisture conditions of soil, creates in Keoladeo, a unique ecosystem consisting of a diversity of habitats — swamp, shrub, wet prairie and dry savannah — that attracts a variety of land and water birds, as well as animals.

There are many other known and unknown wetlands in the country where water birds assemble in different seasons. What makes Keoladeo unique is its strategic location as a staging ground for migratory birds arriving in the Indian sub-continent before they disperse to various wetlands in the country. It is also a site where waterfowl and other migratory birds converge before departing to breeding grounds in the western Palaearctic region. Many of the waterfowl that come here, stay until their return migration. Thus, Keoladeo is the country's biggest congregation point for waterfowl. In addition, it is the only regular wintering area in India, probably in Southeast Asia, for the rare and endangered Siberian crane. Last, but not the least, Keoladeo has one of the world's most spectacular heronries, which hosts a large number of resident water birds. The birds assemble here at the onset of the monsoon, starting breeding activities as soon as the rains start in the last week of June, when

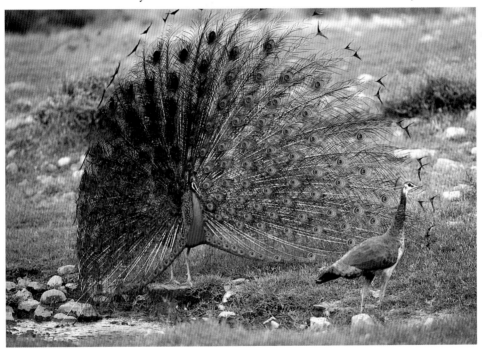

Fanning his tail in full, glorious display, a peacock dances to entice a hen..

(Facing page) The trailing tail feathers of the peacock make it the most magnificent bird of the Indian countryside.

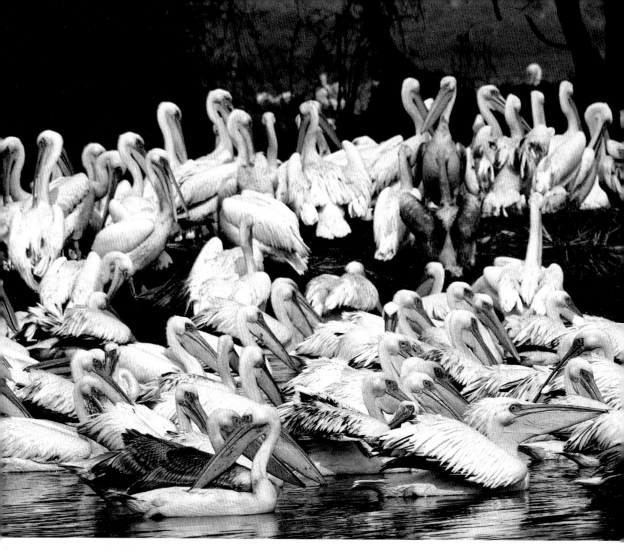

Pelicans are regular visitors to the Park though their numbers depend upon the availability of fish.

the lakes are full and the birds assured of water and, therefore, food. Keoladeo's heronry is unparalleled, not only in the Indian sub-continent, but also, probably, in the world.

The United Nations Educational Scientific and Cultural Organisation (UNESCO), in its ninth meeting on World Heritage, considered Keoladeo as unparalleled in the world and approved it as a 'World Heritage Site' in 1985. The Committee found the wetland of Keoladeo to be the best in the country and recorded in its report that the development of Keoladeo was the result of wisdom and efforts of man. Keoladeo's natural prosperity is clear evidence of the fact that if man utilizes his intelligence in a proper way, he can create conditions conducive to the development of wildlife and maintenance of an ecological balance.

The Committee pointed out that, although there are over four hundred similar wetlands in India, Keoladeo is distinguished as the most spectacular breeding ground of more than 15,000 birds of 15 species that come to nest on its trees, many more in the marshes. It is here that the unparalleled annual congregation of thousands of migratory birds takes place.

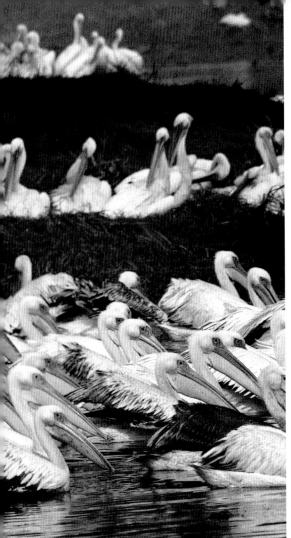

The Creation of a Sanctuary

The area of Bharatpur where Ghana, now the Keoladeo National Park, is situated, used to be the land covered by the overflow the Gambhiri and the Banganga rivers. While some of this floodwater would drain away into the Yamuna, a great deal would accumulate in low-lying plains around. This ideal habitat for antelope and deer was a favourite hunting ground for officers at the Agra cantonment. In 1850, the Maharaja of Bharatpur converted the area into a protected deer-shooting site. The survey report of the British Deputy Governor-General of Calcutta titled *Pargana Roopwas and Rudawal and part of Bharatpur and Kumher in 1856-57,* describes "a large area adjoining Bharatpur which forms a flood plain and water spreads all over. After the rains, the water at many places becomes saline and salt is extracted from it in summers."

The Kola Dahar grassland is a favourite haunt of a variety of land birds.

After the British Government forbade the production of salt by local people, efforts were made to grow wheat and sugarcane, but in vain. Cultivation of the aquatic vegetable 'singhara' was also tried as an experiment. In 1896, the construction of the Jatoli Canal was started to bring water to Ghana. At the same time Mr Devenish,

The report reiterated that while there are bigger wetlands than Keoladeo in some of the neighbouring countries, it is only to this wetland in the Indian sub-continent that the Siberian Cranes, threatened with extinction, come to spend the winter.

This World Heritage Site is not wholly a natural wetland. Human interrention has played a significant role in shaping it. For the last eighteen decades, the Park has been painstakingly managed and maintained in such a manner that it has surpassed the best of natural wetlands, developing into the finest bird sanctuary in India.

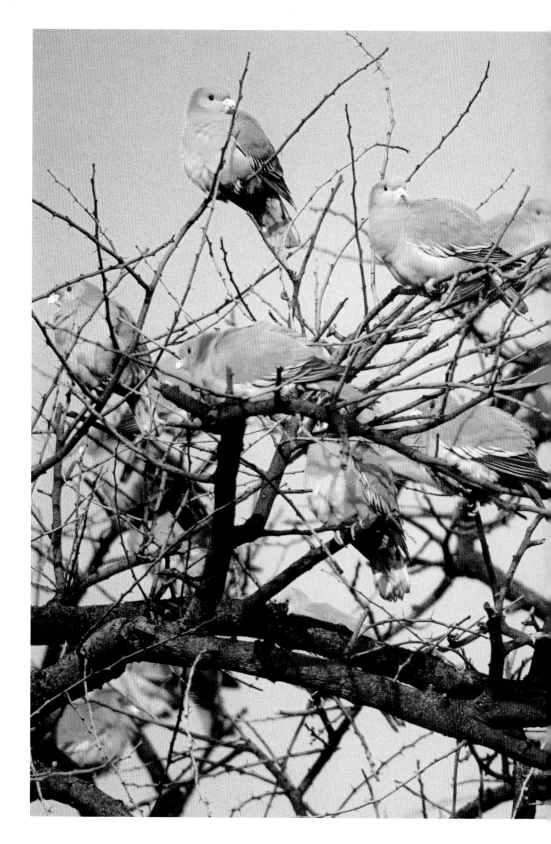

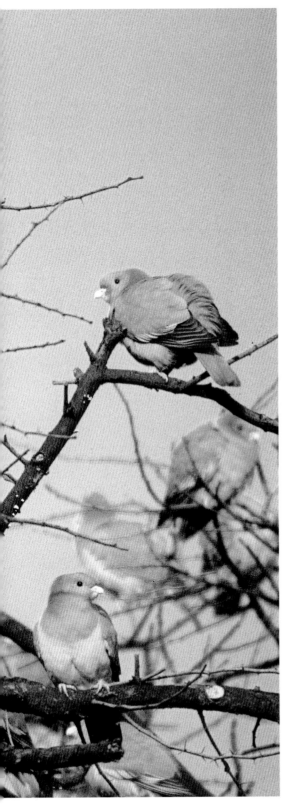

A flock of Yellow-Footed Green Pigeons basking in the morning sun.

an engineer under Col. Loch, who was Political Agent here at the time, prepared a plan to push feral cattle out of Ghana and put a barbed wire fencing all around. Unfortunately, feral cows continued to be a problem and there are a large number of such cattle in the Sanctuary even today.

In 1898-99, insufficient rains caused drought and famine conditions in Bharatpur State. The Maharaja of Bharatpur was a minor at the time. The Regent, Prince Harbhanji of Morvi State in Gujarat, was responsible for initiating the systematic development of this area, beginning with the routing of water into the lakes of Ghana when there was abundant rainfall during the monsoon.

This abundance created a wetland that came to be frequented by thousands of water birds. In 1901, all the lakes of Ghana were filled with water and system of sluicing water from one lake to another was developed. That year witnessed a larger number of birds as compared to the previous one.

Looking at the congregation of birds here in the winter, the Maharaja of Bharatpur invited the Viceroy, Lord Curzon, for a shoot. On December 2, 1902, the first royal shoot in Ghana was held. Encouraged by this shoot, some walking trails and butts were made for the next big duck-shooting event in 1903. In 1905, Lord Curzon, who had taken a fancy to the 'Ghana Duck Shooting Resort', entrusted the job of making a management plan for Ghana to a trained European Forest officer. Under this plan, the Ajan Bund, on the confluence of the Banganga and the Gambhiri rivers, built by the Maharaja of

Bharatpur between 1726 and 1763, was repaired, and the Chiksana Canal constructed so as to release more water from Ajan Bund to Ghana.

In 1910, a Wildlife Department was formed under the 'Bagar' department of Bharatpur State and in 1912, Game Rules were laid down for hunting expeditions. In 1916-17, a part of Ghana Lake was converted into the Mallan Dam to make up for insufficient water in years of scarce rainfall. Then, in 1919, the area of Ghana Game Sanctuary, stretching between 77° 28' to 77° 35' latitude and 27° 13' to 27° 7' longitude, was demarcated and adjoining areas allotted for agriculture and colonisation.

By now, Ghana had become famous for duck shooting all over the country. A large number of British officers and Indian princes started coming here for game shoots. This inspired the Maharaja of Bharatpur to pay greater attention to Ghana, and development works in the area proceeded in a planned manner. In December 1921, a beautiful gate was constructed (which still stands as the main entrance to the Sanctuary). In 1924, concrete was put down on the walking trails to make them more comfortable and durable.

The Bharatpur Forest Act was enacted in 1925 to ensure safety of the flora and fauna. Rules were made for all the game sanctuaries of the State under this Act. After this, for the first time, a Forest and Hunting Department was formed for the smooth management of forests, with powers to ensure the security of Ghana and other forests. Under this Department, one Assistant Forest Officer, one Head Rakhoiya (Dafedar), 21 Forest Guards, two fishermen, one sweeper, one washerman and a gardener were appointed in Ghana.

Over 1928-30, the Sanctuary was circled by barbed wire fencing – the expenditure incurred, Rs. 2826! Once security arrangements were in place, in addition to waterfowl, animals such as sambar, chital, wildboar, etc, started inhabiting the Sanctuary. Two panthers were also released. Between 1930-35, further

reforms were made in the forest works of Ghana, a nursery was developed and Babul trees planted all around the lake.

Following Independence, in 1947- 48, a large area around Ajan Dam had to be given up to agriculture under pressure from farmers. On March 13, 1956, the State Government declared Keoladeo Ghana a bird sanctuary, though the former princes of Bharatpur were given permission to hunt here. In 1967, on the recommendation of the Forest Management Officer, the final area of Keoladeo Ghana was accepted by the State Government to be 28.723 sq. km., though it was only in 1972 that the hunting rights of the former royalty of Bharatpur were terminated and the area accepted as a complete sanctuary. Keeping in mind the pressure for land from the adjoining villages, a masonry wall was constructed all around the Park between 1977 and 1980. In 1981, it was given the status of a National Park and named Keoladeo after the ancient temple of Lord Shiva situated within its boundaries.

Keoladeo in Mythology

Hindu mythology subscribes to the view that the landscape of Keoladeo was typical of a considerable part of the Indo-Gangetic Plain. It also places Lord Krishna in this area. When he was young, Lord Krishna vanquished demons that resided here in disguise. One of the demons, Kalia, disguised himself as a huge python with a hundred heads, while others appeared as large egrets and a crocodile. The supposed battleground of Lord Krishna and the demons is only 45 kms from the marshes of Bharatpur. All these animals are common to the marshes and have been found in this habitat (of course, the python has only one head). There are also to be found solitary as well as clusters of lofty Kadam trees standing at the banks of the marshes where, according to legend, Lord Krishna hid the robes of *gopies* while they were bathing in the lily pool.

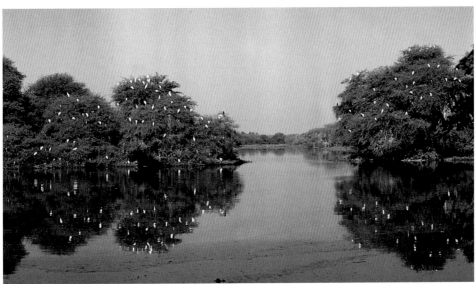

Active after sunset, as their name suggests, the Night Herons spend the day perched upon the many Acacia trees in the Park

(Facing page) Jatoli wood swamp has the most impressive vegetation of the Park. These Kalam (Mitragyna parvifolia) are almost 100 yrs old.

The Magnificent Wetland

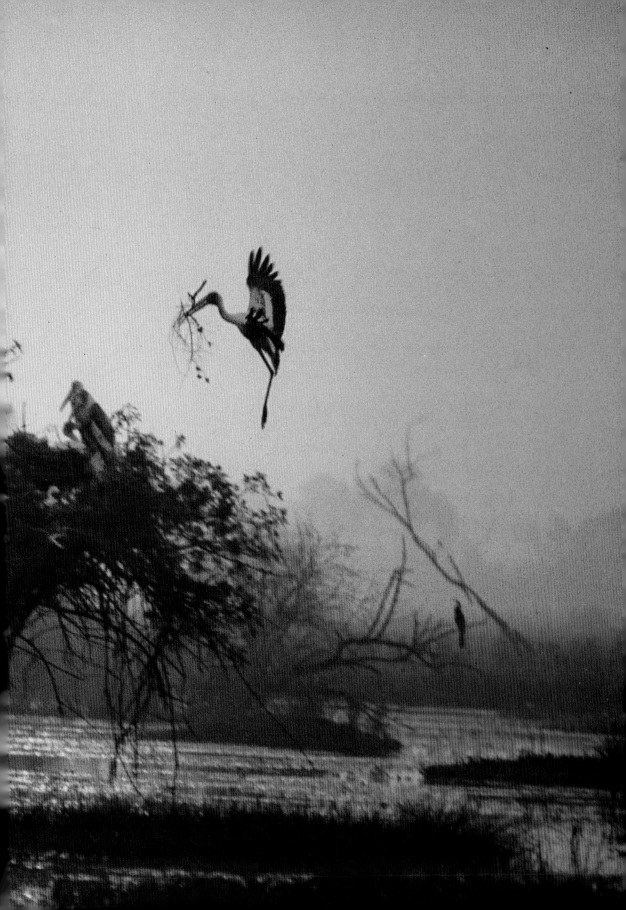

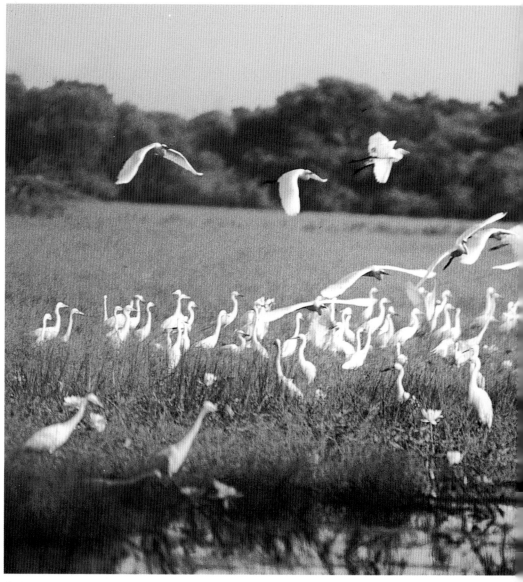

Keoladeo National Park is situated at the North-western end of the Indian Peninsula in the great plains of the Himalayan foothills between 27° 7.6' to 27° 12.2' N and 77° 29.5' to 77°33.9'. The climate here is sub-tropical, characterised by a distinct summer, monsoon and winter. Summer commences at the end of April when the days become warm. May and June are known for the intense heat with temperatures that touch 50°C (BNHS Annual report). Nights remain pleasant with temperatures lower than 30° C. The intense heat dries up the Park, leaving only the water-bodies. Eventually these pools are also transformed into tiny bowls of slush that, as they dry, are abandoned by turtles and other aquatic life that can move on. The fish, which the lowering water levels make vulnerable, attract numerous fishing cats, otters,

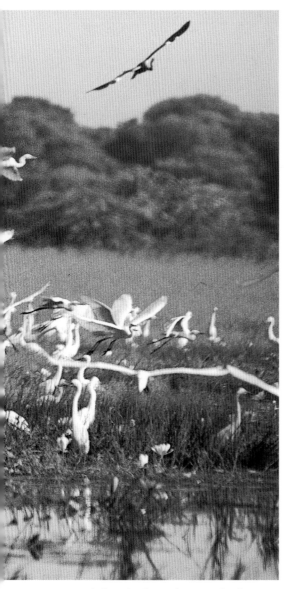

being deeper, usually retains the most water and serves as a reserve where the fish breed.

In Keoladeo, maximum rainfall occurs during the monsoon, which begins in July. There may be a few showers in June, but it is the heavy, dark clouds that, as they fill the sky in the month of July, raise hopes for rain and water. The healthy fragrance of the monsoon winds thrills all forms of life. The first shower acts as a magic touch. Deer and antelope can be seen enjoying the rain and cuckoos start singing. Peacocks and brain fever birds raise their high-pitched voices as if urging the rain-gods to shower more blessings. The rains, which continue till the middle of October, dramatically transform the Sanctuary into a thick, green mass of land.

The days are moderate in October and nights become cooler. As the winter commences, from November onwards it gets colder, days become shorter and the nights longer. December and January are very cold and sometimes night temperatures drop to 1°C (BNHS Annual report). Frosty nights are common and occasionally the frost burns the taller trees. Often a thick mist impairs vision beyond fifty meters, though this usually clears with sunrise, and the day is sunny. In February, temperatures begin to rise and migratory birds start preparing for their return flights. By now, the day has become longer once again and the breeding activities of land birds are in full swing. Summer establishes itself by April-May and the testing time for all forms of life begins. The circle is complete.

Egrets assembling for the morning feed.

(Previous page) As the winter dawn breaks over the Kcoladeo National Park, endangered Painted Storks tend to their nests.

even jackals, which can be seen feeding on the fish now that they are easier to catch. Egrets assemble near these drying pools to feast collectively. Vultures and Adjutant Storks can also be seen, though the Adjutant Stork is becoming a rarer sight by the day. Egyptian Vultures arrive to claim their share of fish. Despite this abandoned feasting, however, many fish die and decompose in the mud and slush that mark the vanishing pools. Mansarovar,

The Flora

Keoladeo has a varied floristic composition. The richness and diversity of plant life inside

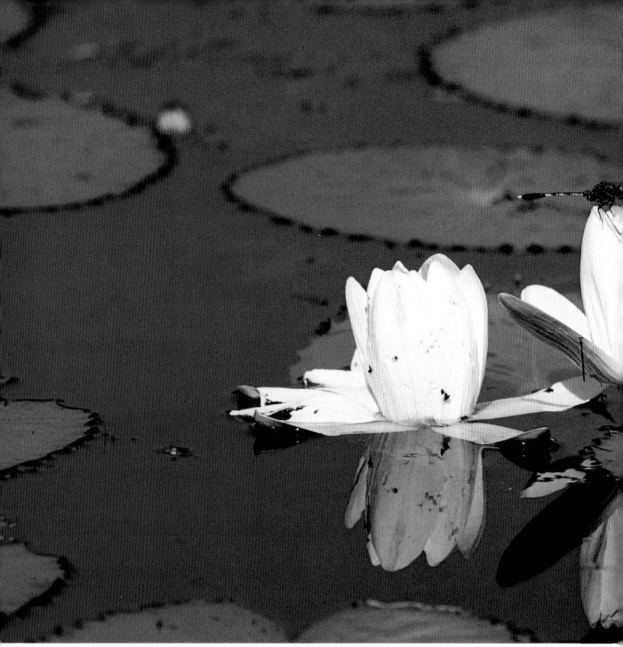

this small Park is remarkable. The vegetation here can be divided into ten groups. Most of the area, however, is under woodlands, dense thickets, savannah with shrub, scattered shrub, grass savannah and low grassland. The flora consists of 377 species of flowering plants, of which 96 are wetland species. The 287 species of vegetation consist of 41 species of trees, 32 shrubs, 156 herbs, 24 climbers and 29 different types of grass. The 91 species of wetland plants comprise 5 free floating, 4 free submerged, 5 rooted with floating leaves, 7 rooted submerged, 18 emergent and 52 species of marshland plants (BNHS report).

A large part of the Park can be categorised as wet prairie where wild rice, a different species of *Oryza* grows in shallow water. The marsh is filled with flowering *Ipomea*. The ponds are choked with

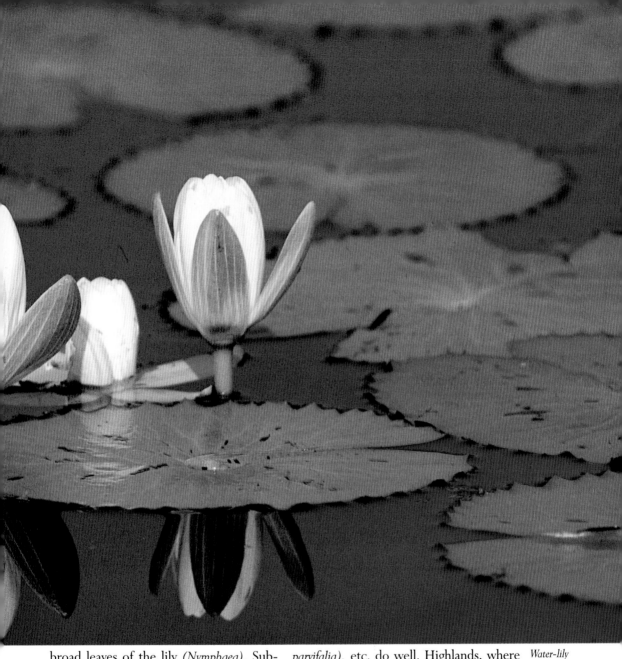

Water-lily (Nymphaea Nouchali) in bloom. These flowers open at night and close under the warmth of the sun.

broad leaves of the lily *(Nymphaea)*. Submerged plants such as *Hydrilla, Nagas, Vallisneria, Ceratophyllum* and *Potamogeton spp.* make up the major food source for waterfowl. The higher areas, which are flooded only for a short period, are covered with Khus – species *Vitivaria*, a coarse grass. On deeper soils, deciduous species of Babul *(Acacia nilotica)*, Ber, *(Zipiphus mauritiana)*, Kadam or Kalam *(Mitragyna parvifalia)*, etc, do well. Highlands, where water seldom reaches, are saline and are colonised only by halophytes such as *Salvadora presica, Salvadora oleoides,* etc. Rich soil, bright sun and the highly nutritious water is all that is needed for plant growth.

Usually vegetation appears as the lake gets flooded towards the end of July. Flowers can be seen covering the surface of water within forty days of flooding and the growth

(Below)
During the monsoon Ghana receives almost 65 million fish fry and fingerlings from Ajan Bandh

(Right)
As assembly of pelican. Both noisy and spectracular, such gatherings are a common sight in the Park.

rate is higher when the lake has open water. In slightly deeper water, lotus-like white flowers take hold and spread their broad leaves. These are water lilies of *Nymphaea* species. Kumudini's *(Nymphaea Nouchali)* tender white flower remain closed in the warmth of sun but opens in the cool of night. In the morning, when thousands white flowers are still open, they look like pearls spread on a green carpet. At around eight in the morning as sun becomes warmer, these flowers start closing. But there is another lily, *Nymphaea stellate,* which blooms in sunlight. The flower of this species is of the same size as of *N. Nouchali,* but its

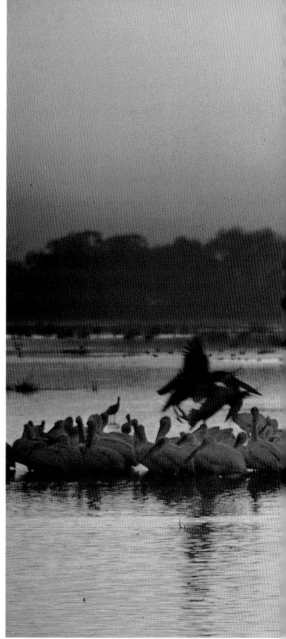

pointed petals have faint bluish tint. The smallest water lily is *Nymphoides cristata.*

Lilies can also be seen in open water patches in the midst of *Paspalum distinchum* grass. They bloom up to October. Then, as it gets cooler, they start disappearing from the surface of the lake. By the end of November, not a single lily is to be found in the Park.

Major species of plant associated with these lilies are *Spirodela polyrhiza, Sagittaria segitilolia, Ipomea aquatica, Portulaca olearacea,* etc. *Nymphoides indicum* is a typical example of a free-floating flower. After germination, its stem or roots get detached from the rhizome, to absorb nourishment directly from the water.

The Park still has Kadam *(Mitragyana parvifolia)* trees. The groves near Sitaramji Temple are more than a hundred years old.

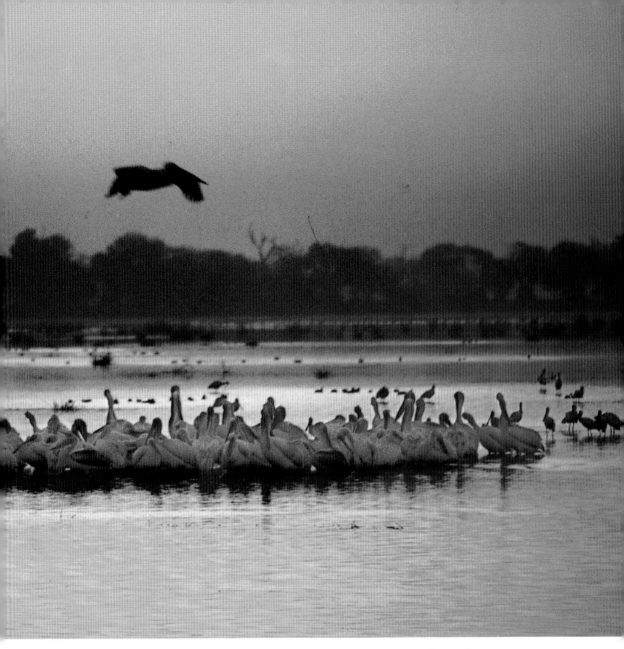

Babul *(Acacia nilotica)*, Roonj *(Acacia leucophloea)*, Ber *(Zizyphus mauritiana)*, Khejari *(Prosopis cineraria)*, Vilayati Babul *(Prosopis chilensis)* are common trees found in the Park. Herbs constitute more than 55 percent of the floristic species. Some areas are dense thickets, interspersed with trees six to twelve meters high.

Keoladeo is also known for Khus *(Vetiveria zizanioides)* grass. Other most widespread grasses in the park area are Aincha *(Paspalum distichum)*, Lala *(Aristida spp.)* Dab *(Desmostachya bibinnata)*, Munj *(Saccharum munja)* and Dub *(Cynadon dactylon)*. Jal kumbhi or water hyacinth *(Echhiornia crassipes)* and *Prosopis chilensis* are the most common weeds in the Park. Water hyaciath spreads very fast since water is taken from one block to another block. Park management removes this weed manually

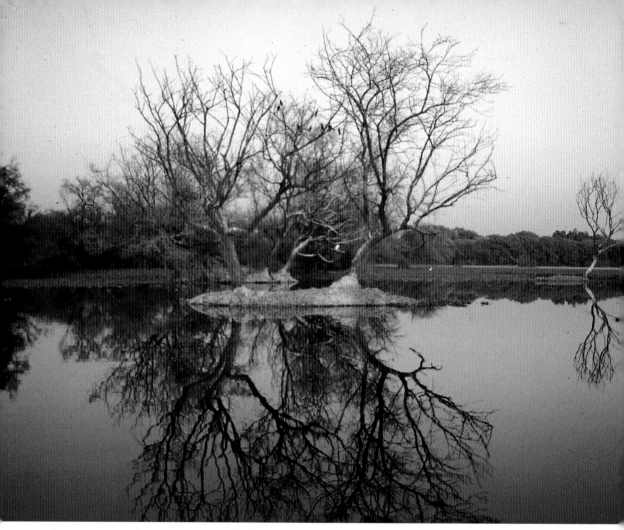

on a continuous basis. *Prosopis chilensis* is also considered a weed as it has little wildlife value other than providing shelter and suppresses other vegetation. Extraction of this is also a problem.

Biological activity in this area catalysis during the monsoon. Germinating seeds, fish and hatching amphibians as well as hibernating animals, all resume a kind of new and active life. More biological activity means more food for all living beings. The rich biomass helps the growth of fish and frogs, on which water birds like egrets, herons, storks, darters, cormorants and other birds feed. In the month of October, when the lakes are filled to their maximum, chicks of breeding birds are on the wing and start feeding near the lakeshores. The wetlands seem to extend a kind of invitation to thousands of water birds, which, in turn, attract raptors such as eagles, owls and hawks. Every day, few thousand migratory birds, especially ducks and geese, land on the lake. Groups of waterfowl such as Greylag Goose, Pintail, Common Teal, Gadwall, Wigeon, Blue-winged Teal, Shoveller, Red-crested Pochard, Common Pochard, Coot, etc, become part of the lake. These are followed by waders. In this season, every part of Keoladeo Lake houses these birds. Waterfowl cover almost the entire water surface. When they rise

together with a beat of wings like a thunderclap, it is a sight worth beholding.

Water Management

As the whole ecosystem of the Park revolves around water, the management of water levels is, obviously, critical. Water is brought in from Ajan Dam through Ghana Canal passes through the Park and enters Jatoli Village on the other side. The sluice gates at strategic points on the canal, regulate the flow of water to each block where it is contained by the means of earthen dykes. Blocks without direct access to the canal receive water routed through other blocks. Prior to the construction of Panchna Dam, there was a natural drainage system whereby the waters from the Gambhiri and Banganga rivers drained into the Ajan Bund. Now water from the Gambhiri River (which is a bigger river as compared to Banganga) is collected in the Panchna Dam in Karauli district.

When water is released from Panchna Dam, it is routed through the Gambhiri River and Panchna Canal into the Ajan Dam. After it reaches the eight feet mark at Ajan Dam, it is released into the Ghana Canal through Dakan Mori that brings water to the Park. All areas with breeding colonies are filled first. When the canal is full, water is released in L and LW blocks. Thereafter, N block, which connects to LW block and also the colonies of breeding birds, is filled. Water is released to K, E and F blocks. It is only after all these blocks are full to a depth of more than three feet, that all other blocks are filled with water routed through these blocks.

The total annual requirement of the Park is estimated to be 500 m cubic feet water. The intake is 10-15 m cubic feet per day depending upon the release from Dakan Mori. This is distributed in ten blocks through 16 sluice gates that control the routing of water. It takes six to eight weeks to fill the Park's lakes.

(Below)
A small member of flamingoes also visit the park at the end of winter or during the spring when the water is low and brackish.

(Below Left)
A female Purple Sunbird feeding its chick.

(Facing page)
Weird and wonderful reflections in the lake.

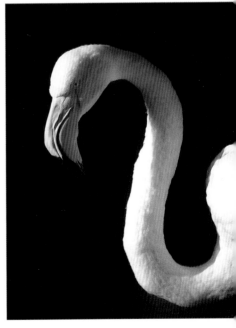

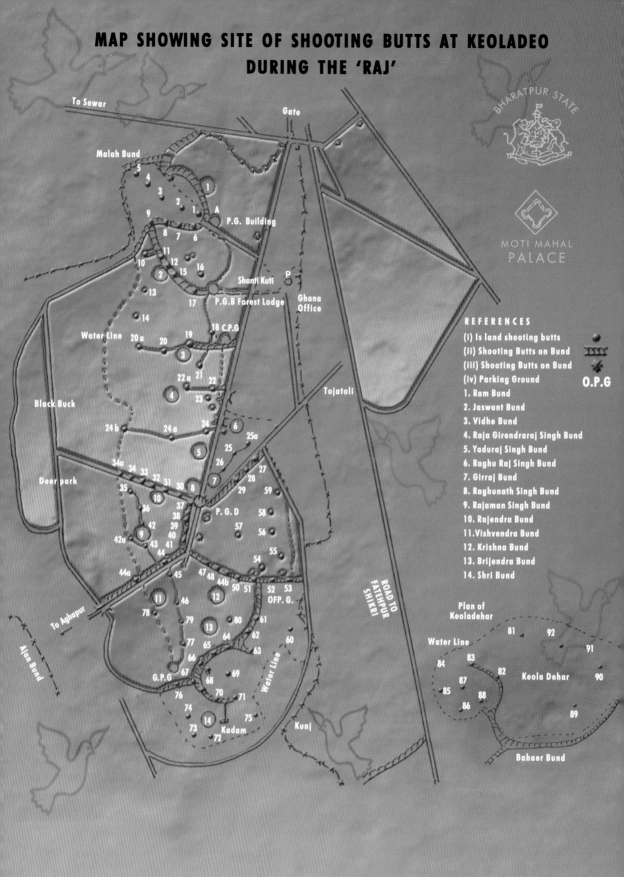

A Favourite Duck Shooting Spot

Ghana, as Keoladeo used to be known, is famous in the hunting history of India. Thousands of ducks were shot here between 1902 and 1964. In 1902, the Viceroy of India, Lord Curzon, shot 540 birds with 17 guns at his inauguration shoot. In 1912, Viceroy Lord Hardinge shot 3511 bird with the help of 51 guns. During his second visit in 1914, Lord Hardinge bagged 4062 ducks. In 1916 Viceroy Lord Chelmsford shot 4206 birds with 50 guns. King Edward VIII also visited Bharatpur as Prince of Wales on December 8, 1921. He and his party achieved a score of 2221 with 53 guns. The world duck shooting record was established here on November 12, 1938, when 4273 ducks were shot between 7.00 am and 5.00 pm. (including a break of two hours). That day, 3044 birds were killed in the morning and 1229 in the afternoon. Lord Linlithgow established the record for firing maximum rounds and killing about 2,000 birds.

In 1959, the Department of Tourism, Government of India, in an attempt get publicity in the American press, invited Jack Denton Scott, an American journalist, to write about hunting in India. During this visit, Mr. Scott stayed as a guest of Maharaja of Bharatpur and participated in a duck shoot. He described his experience in his book *Forests of the Night* published in 1960. Incidentally, Mr. Scott's name is engraved on the pillar posted in front of the Keoladeo Temple in the Sanctuary. This is what he

The flight of Greylag Geese at sunset. During the 'Raj' this freshwater swamp was used as a duck shooting resort.

says:

"Maharaja and I left to look at the area where we would shoot ducks. The water, shallow as a swamp, gleamed like dull pewter in the later afternoon sunlight, covering an area, encircled with ninety-two shooting butts, that would have taken a couple of days to walk around. 'Seven thousand acres', the Maharaja said, 'a favourite stopping off point for wildfowl on their way to Siberia to escape the heat of India'. On the way to the water he had stopped and explained a large upright white marble table with the names of Viceroys of India, princes, the internationally famous, chiseled in the stone with the date of their shoot and the number of ducks bagged on each particular shoot.

'This is called Keoladev Ghana', the prince said. 'It has been the favourite duck shooting spot of my ancestors for over one hundred years'.

We passed back through the graceful marble arch of the Prince of Wales Gate that marked the entrance of the shooting area and returned to the palace. We went to bed early get ready for the duck shoot, after the Maharaja had given us a heavy envelope closed with the royal seal of the House of Bharatpur. 'This will tell you more about the duck shoot', he said. 'See you in the morning'.

I sat on the huge bed and read the document printed in royal blue ink on fine parchment paper. It read:

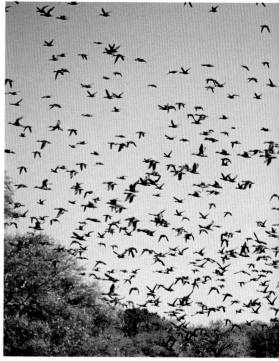

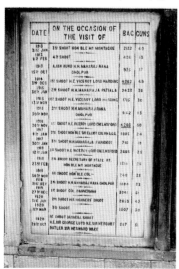

Your Butt No.15. Enclosed please find
1. Map of Ghana with butt indicated on it and the route thereto.
2. Cards for return of game shot and picked up (Two copies, one for morning and the other for afternoon).

Please note the following instructions -
a. No shot should be fired before the canon sounds at 8.30 a.m. and after the gun sounds at 12. Shooting will recommence at 3 p.m. and will continue till dark.
b. The coolies (pickers up) are engaged for the day and the guests are requested to pay them Rs.____/- each. The payment should be made on presentation of a card by each coolie. The card should be handed over to the A.D.C. on duty to avoid double payment to the coolies concerned.
c. When you have finished shooting in the morning, please fill in the appropriate

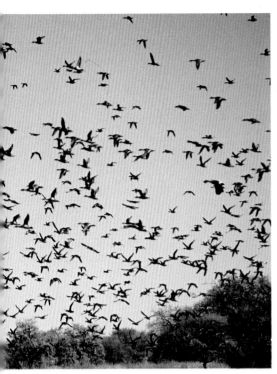

any four-legged animals in the Ghana forests on their way to duck shoot.

The royal duck shoot sounded like quite an operation. The map showed the lake and the position of the butts. The list of names at the back it read like pages ripped from a history book, leading off with H.E. the Commander-in-Chief Lord Kitchener, and ending with H.H. the Maharaja, Governor of Mysore, the dates running from 1902 to 1958. The last shoot in this year had been in January when the flight of ducks was heavy. Now in March, there still would be ducks, but not the concentration that there was earlier. The heat was poised now, ready to envelop the country like a damp electric blanket turned on its high setting; and the blast furnace that is India from late March right straight through until November, had its door slightly ajar.

Then he adroitly changed the subject, asked us about our shotguns, whether we had cartridges. "I think that it is time to go. We should be there by eight-thirty at the latest. We keep the ducks flying by shooting from the butts. No decoys or anything like that. I've asked the entire faculty of Bharatpur College to take the day off and shoot with us. They will have fun and they will help keep the ducks in the air. We will all have dinner here afterwards. Duck curry. I think you will like it."

The shooting butts were woven of bamboo, placed in positions perhaps twenty-five feet from the water. The teachers had arrived and were already in

(Left) Different varieties of ducks visit the Park every winter. These clouds of ducks provided an easy target to the shooter during the 'Raj'.

(Below and the left page) At Keoladeo Temple is engraved the record of ducks, that were slaughtered here from 1902 to 1964.

"Return of Game" card and hand it over to the clerk at Prince of Wales Gate. Again on the conclusion of evening shoot "Return of Game" card should please be handed over to the clerk at the Prince of Wales Gate.

d. Guests are requested to bring their own bags to Moti Mahal. Game will be supplied on request from A.D.C. on duty.

e. Cartridges will be sold on cash payment at the price prevailing in Delhi and Agra markets, i.e., Rs.___/- per 100. Cartridges once sold will not be taken back.
Cartridges can be had at Moti Mahal, Shanti Kutir and Keoladev.

f. Guests are requested to kindly note that if there are any metal rings on the leg of the birds' shot, they should make a note of the number and inform the Private Secretary.

Note - Guests are requested not to shoot

(Below) Flight of ducks at sunset

(Right) A very rare picture of the Maharaja of Bharatpur sitting with his guests after the royal duck shoot

the butts. We came in the Maharaja's Jeep, a station wagon with a custom body large enough to seat a dozen people. Our "retrievers" were waiting for us, two to a butt, one to hand us a loaded gun, the other to wade into the water and deliver the drowned ducks. The Maharaja moved to a butt about a hundred yards from me; Mary Lou was the same distance behind me in the butt the Shah of Persia had used a couple of months before. We were to wait for the Maharaja to fire first, signaling that the shoot was to begin.

Two sharp reports: The prince had begun. Then a series of blasts from a distance, the teachers were shooting. The ducks came in high and fast, spurred into action by gunfire

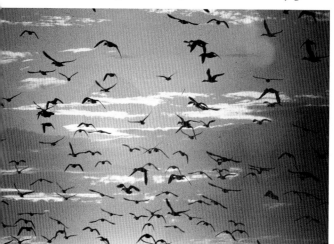

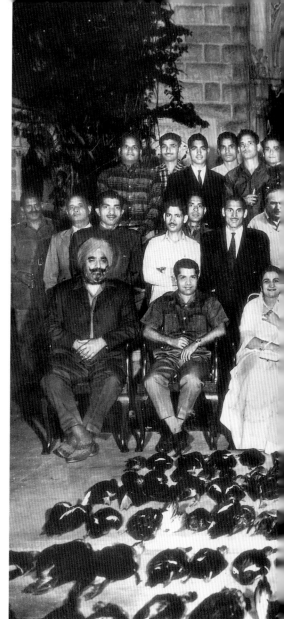

and they were not easy targets. Ducks never are. I have alibis. I'm a point-shooter over decoys, or a pass-shooter, but these ducks were in full flight, alarmed and flying high, but within gun range. I swung at one that looked like a blue-winged teal, and fired. He kept on going. My butt boys giggled. Gunfire was resounding from all over the place now and the Maharaja and Mary Lou were blasting away. Finally, I made contact and ducks began to fall. My retriever, a lad of about sixteen, rubbed oil on his legs and waded after them.

As my pile of ducks grew I tried to identify them. Some were teal, the blue-winged and cinnamon, and strange types later identified for me by the Maharaja; whistling ducks, Andaman teal, pink-headed ducks. I must admit that the Maharaja kept his boys in the water most of the time but mine didn't get too wet.

Then it was over and the Maharaja came marching back, followed by his butt boys who

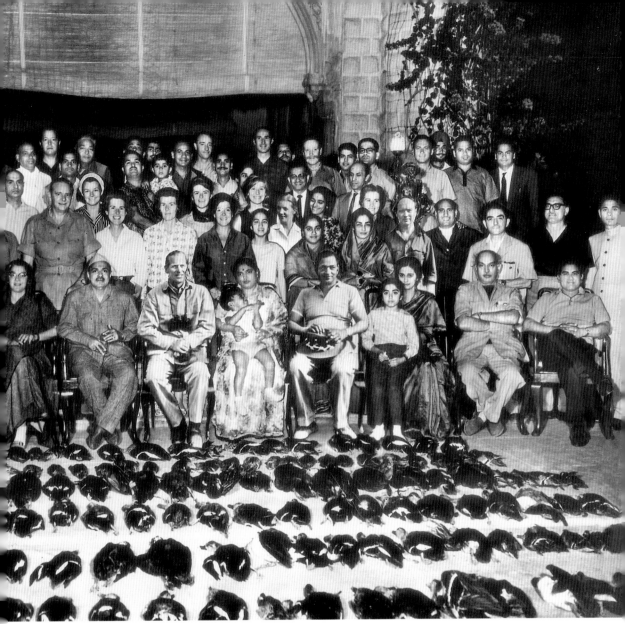

were loaded with ducks. He had fired three boxes of cartridges and had seventy ducks. The man was a master, probably the best wing shot I have ever known. I had twenty-five, Mary Lou about a dozen; the teachers brought in another fifty. Enough for dinner, which the Maharaja would cook".

How many birds were butchered in Ghana can be judged by looking at the dated record engraved stone in front of Keoladeo Temple from 1902 to 1964, although it contains the list of birds killed by VIPs only and not others.

Despite this spree of duck shooting, the forest officers of this sanctuary have managed it so beautifully that Ghana is not only prospering in these extreme drought-like conditions, but there is an addition to the number of birds that come here every year.

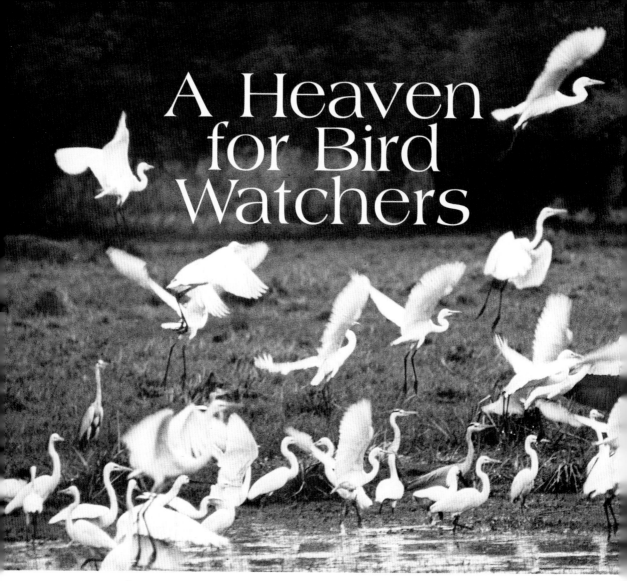

A Heaven for Bird Watchers

Today, the environment of this Sanctuary is peaceful and tranquil, which makes it a paradise for the birds as well as bird-watchers, naturalists, writers, wildlife photographers and biologists. The major group of birds that visit the lake are egrets, herons, ducks, geese, teals, coots, moorhens, cormorants, darters, storks, ibis, etc. The number of these birds is highest in the colder months of December-January and drops in the summer. As soon as the migrant birds arrive in the Park, the number and species of aquatic birds increases.

My own association with the Park is a very long one. I have been coming here regularly since my first visit in the winter of 1976 when I was still in college. That year the lakes were full of waterfowl. Since then I visit the Park more than 6 times a year and stay for 4-5 nights at a stretch. I have seen good years when it has rained and the Park was full of birds, as well as a time when monsoon failed.

1977 and 1978 were normal years and birds followed their usual schedule for

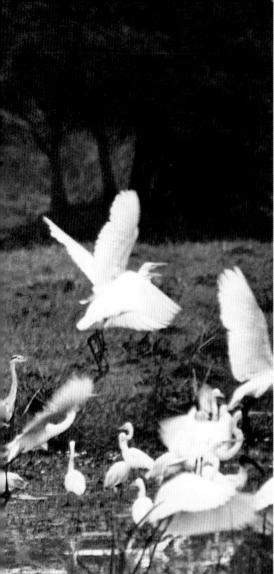

was almost full and water could be released in time. By the end of July, all the lakes were flourishing. There were more than 6200 nests recorded that year, the maximum number of these belonged to cormorants.

1981 was good for Painted Storks and egrets. More than 1,800 nests of Medium or Intermediate and Little Egrets were counted, 68 of Great Egrets; 1700 nests belonged to the Little Cormorants and Shags, 364 to Great Cormorants and Grey Herons; around 1000 to White Ibises; and more than 400 to Darters. In 1982, these

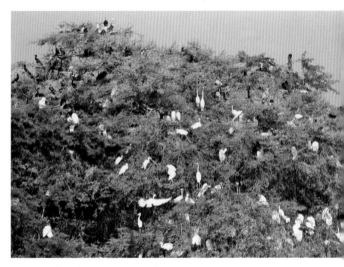

breeding in the Park. Migratory birds also came in thousands. But the monsoon failed in 1979 and that was a draught year for the Park. Ajan Dam was empty and there was no water in the lakes, not even in puddles. The few Open-billed Storks that assembled here in anticipation of rain abandoned their nests and left the Park. Ten tube-wells were bored within the Park boundaries to fill some ponds but they all failed. Not a single nest adorned the trees. Fortunately, 1980 was a normal year. There was rain in Bharatpur and adjoining areas. Ajan Dam aquatic birds constructed 4849 nests – Painted Stork (1232), Shag (945), Medium Egret (633), White Ibises (676), Open-billed Storks (372), Spoonbills (167), Little Egrets (222), Darters (238) were the main breeders.

Rains were good in 1983 and Ajan Dam was full. 4200 nests were constructed. 1984 also saw a good monsoon and consequently breeding activities of water birds were hectic, though the numbers seemed to have declined. A total of 3581 nests were counted. Once again, the Shag and Little

(Above) Nesting egrets and cormorants. During the monsoon one can see more than a hundred nests of different species on single tree.

(Facing page) Egrets snap at surfacing fish, making short flights that follow the movement of fish in the lake.

Cormorant had the biggest breeding population, but the number of other breeding birds in the heronry was normal. Surprisingly, amongst the nests counted there were only 12 made by the darter. Grey Herons had 6, Large Egrets 4, Night Herons 2, and White Ibises 2, There was only a single nest each of the Purple Heron, Cattle Egret and Little Egret found. What was amazing was that the Cattle Egret, which always breeds here in good numbers was less active in the breeding colony. The birds had chosen to nest in nearby villages, even in Bharatpur town. I had seen nests in a Neem tree at the Bharatpur Railway station for myself!

1985 was a very good year for Keoladeo with all fifteen species of gregarious monsoon breeders congregating in the heronry. The Babul trees were full to capacity and a total of 6407 nests was recorded. Birds that were not active in 1984, the Purple Heron, Cattle Egret and Little Egret were busy with their chicks. 1749 nests of the Painted Stork were recorded, the highest in last five years. There were 1554 nest that belonged to shags, 569 to Little Cormorants and 518 nests of Open-billed Storks.

The fluctuation in the nesting population of individual species worried ornithologists and the Park management. It occurs mainly because of climatic conditions – changes in the habitat, rainfall, and availability of fingerlings. If the habitat improves, individual species start breeding again the next year. During 1984, the Little Egret did not make a single nest, but when conditions were good in 1985, it bred in good numbers. Also, more nests does not mean more chicks and an improvement in bird

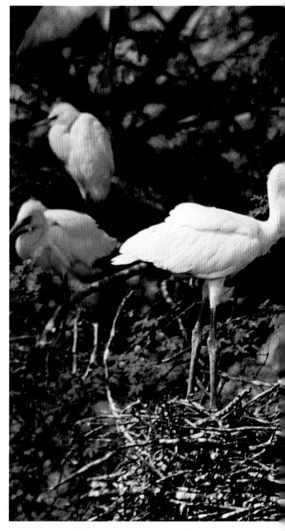

population. The Bombay Natural History Society carried out a study from 1983 to 1985 that compares the ratio of the chicks per nest. Although, 1985 was better for the birds nesting population, the number of chicks in the nest was higher in 1983, There were 1.52 chicks per nest in 1983, 0.17 in 1984 and 1.04 in 1985. The following year, 1986, the monsoon failed again and only 78 nests were successfully hatched.

1987 also witnessed a sparse monsoon and less than 2000 nests were recorded. But 1988 was a good year. The Park received water from Ajan Dam in time. A total of

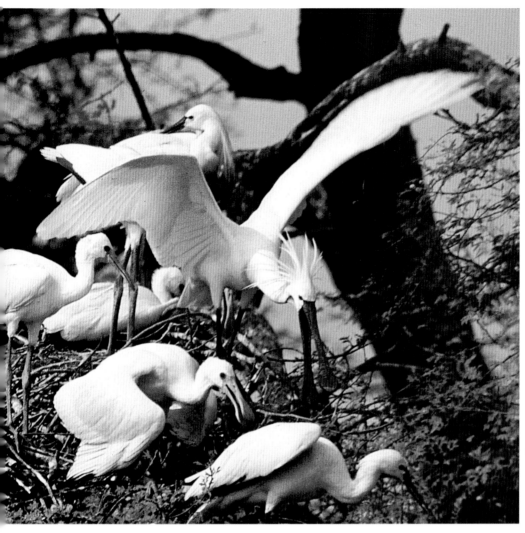

The twig nest of the spoonbill, in which it lays 3 to 4 eggs, is often found in mixed-breeding colonies of egrets, ibises and Painted Storks.

8468 nests were constructed. It was probably the best of the last five years.

1989 was a poor year as far as breeding is concerned. 1990 was also not good, only 1847 nests were made, but a number of good monsoons from 1991 to 1996 saw lot of resident water birds collect in the Park for breeding. 5549 nests were noticed in 1991. They included 670 nests of Open-billed Storks, 459 nests of Painted Storks, 122 of Great Egrets, 29 of Purple Herons and Great Cormorants each, 1084 of the Little Cormorants, 1792 of Indian Shag, 364 of darters, 11 spoonbill nests and 194 White Ibis nests.

In 1992, 6049 nests were constructed. 1993 proved to be a medium year as only 3746 nests were built due to late rains and lower water levels in the lake. But 1994 was again a normal year and 5360 nests were counted. 1995 was better than 1994 and a total 6325 nests were built. The Painted Stork, whoes numbers had been dropping for several years and had not crossed the thousand mark, came in large numbers, building over 1000 nests (1045) for the first time since 1988.

However, to be remembered as a really

outstanding year is 1996. Good rains in the last week of June filled Ajan Dam. Around mid-July, water was released into the Park bringing with it an enormous quantity of fish which, in turn, attracted thousands of aquatic birds. There was very good breeding in the heronry and more than 9050 nests were constructed, a breeding record for the last fifteen years. These included: 1221 nests of Painted Storks, 2332 of Shags, 1186 of Median Egrets, 1010 of Little Egrets, 843 of Little Cormorants, 454, of Open-billed Storks, 766 of Night Herons, 380 of Great Egrets, 165 of White Ibises, 162 of Cattle Egrets, 159 of darters, 145 of spoonbills, 84 of Grey Herons, 87 of Purple Herons, and 56 nests of Great Cormorants.

The number of these nesting birds may have been more. The count had been done in last week of September, and some early nesters like cormorants, shag and egrets had already left their nests with young ones.

Now, every year two counts are done. One in the middle of breeding season and other when the Painted Storks hatch their eggs. That year Abrar Khan, a forester affectionately known as Bholu, observed more than hundred nests of nine different species on a single tree.

1997 turned out to be a total failure for the Park as far as breeding is concerned. There was little rain and only 25 nests were made.

Swinging up again, 1998 was very good year. Rains were in time and lakes were full. The water lily was blooming everywhere. A total of 5929 nests were made: 1799 nests of shags, 1570 of Little Cormorants, 697 of Painted Storks, 393 of Medium Egrets, 277 of Open-billed Storks, 100 of Great Egrets, 273 of Little Egrets, 17 of Cattle Egrets, 26 of Grey Herons, 49 of Purple Herons, 309 of Night Herons (also a record), 49 of Great Cormorants, 143 of darters, 117 of spoonbills and 106

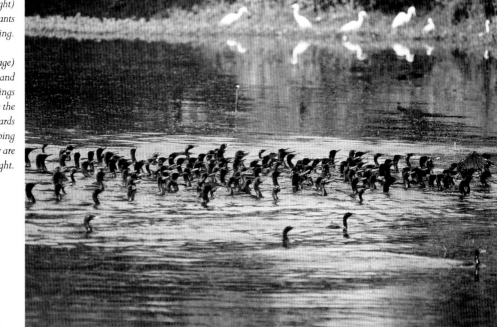

(Right) Cormorants assemble for fishing.

(Facing page) By swimming and flapping their wings the birds drive the fish towards the shore, trapping then so that they are more easily caught.

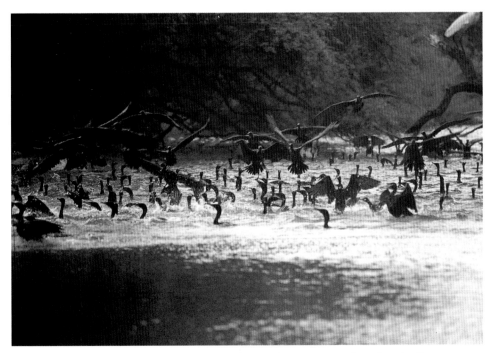

of ibises. The following years, 1999 and 2000, the monsoon failed again. Ajan Dam was empty and there was no water in the Park. Not a single nest was made during 1999. But birds assembled here in anticipation of good rains in 2000. Some started nesting activities but the monsoon failed again and nesting birds abandoned their nests and left the Park.

2001 also witnessed a sparse monsoon and was not a good year for breeding birds as compared to 1996 or 1998 but after two years of drought there was some nesting activity. Only 1,658 nests were recorded. They included 156 nests of Open-billed Storks, 402 of Painted Storks, 320 Little Cormorants, 227 of Indian Cormorants, 16 of Great Cormorants, 49 of White Ibises, 30 of Spoonbills, 20 of Great Egrets, 151 of Median Egrets, 43 of Little Egrets and 51 of Cattle Egrets.

Monsoon again failed in 2002 and there was no water in the Park or Ajan Dam. Not a single nest was made. After the four-year gap there were good rains in 2003. Ajan Dam was almost full to its total capacity. Then farmers stared lobbying for water from the dam to irrigate their fields. Though bird watchers and farm administration demanded water for the Sanctuary, local politicians successfully pressurized the irrigation department into not releasing water to the Park. After a long chase water was released at the end of September. By then, majority of breeding birds had already left the nesting site. Only about 1470 nests were made. More than 500 of Painted Storks, 440 Indian Cormorants, 133 of Medium Egrets, 87 of Little Cormorants, 54 of dartersle, 61 of billed Stroks, 46 of Great Egrets, 60 of Cattle Egrets and 40 of Night Herons and other birds.

These records of nesting activities in the Park highlight its enormous potential. The heronary is the apex of all the breeding activity.

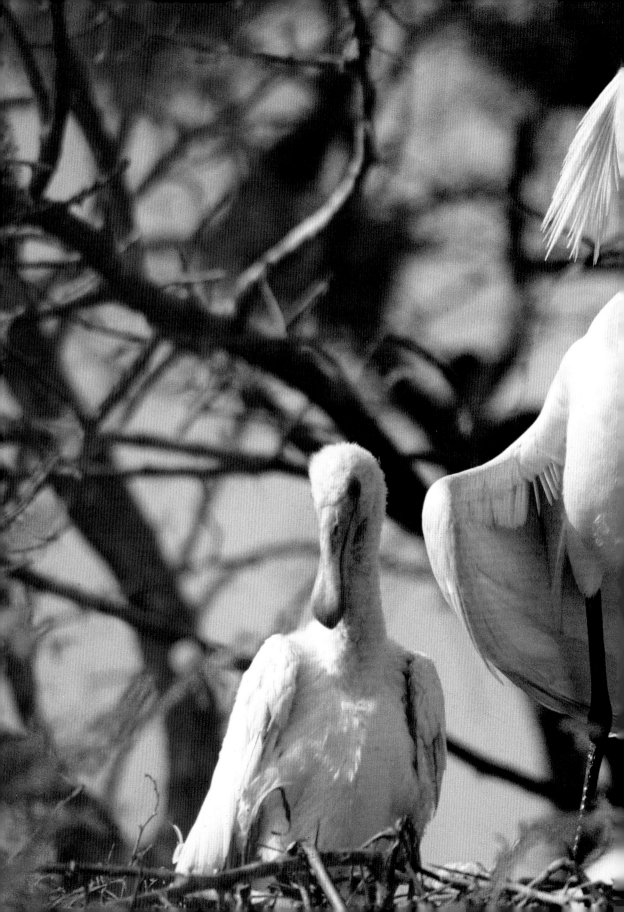

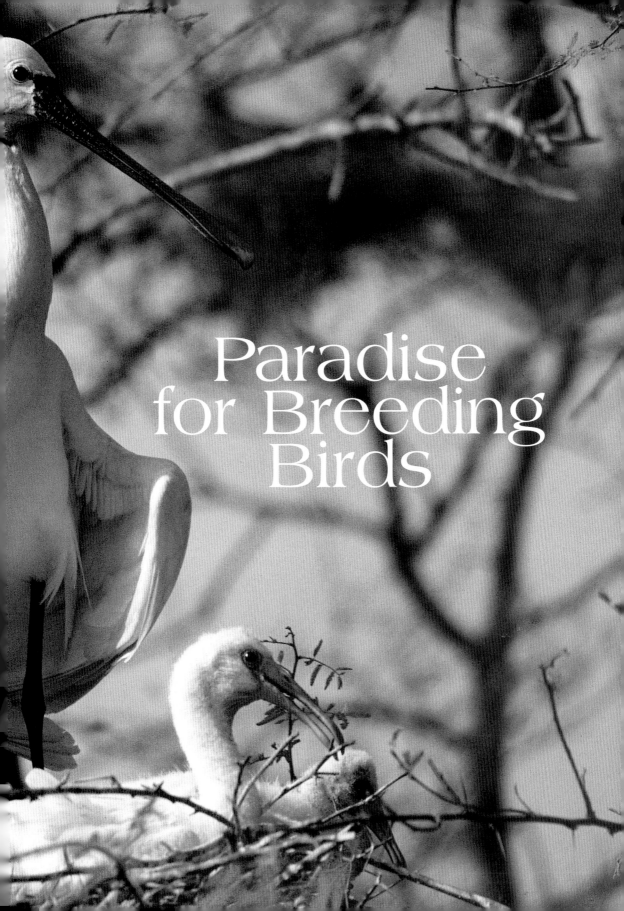

Paradise for Breeding Birds

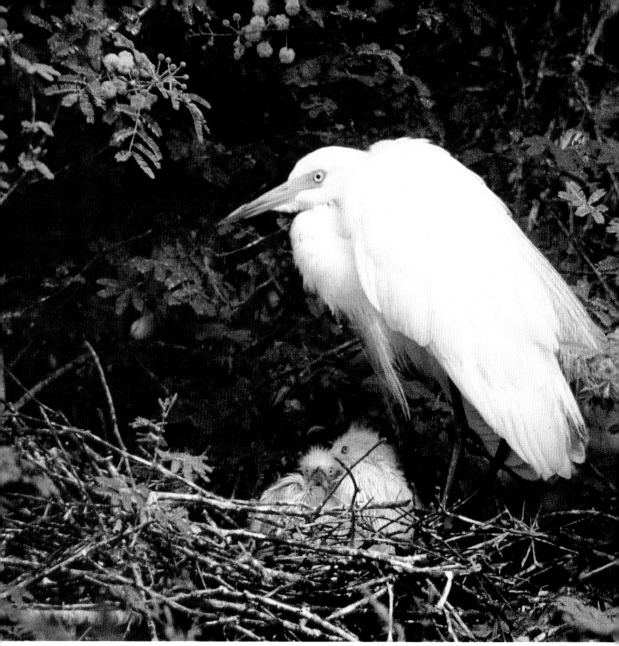

(Above) Intermediate Egret with its chicks. For the first 8 to 10 days they feed on fish regurgitated by both percents

(Previous page) Spoonbill with young ones. During breeding season the bird aquires a long, white nuchal crest.

The breeding of local aquatic birds follows the monsoon rains, beginning in the last week of June and continuing up to the end of September. The gray clouds that cover the sky in the last week of June herald the end of the scorching heat of summer. With the first shower of the monsoon, the atmosphere becomes cool and pleasant. This is when eighteen species of water birds such as storks, cormorants, egrets, herons, etc, gather in Keoladeo to breed, turning the Park into the world's most spectacular bird sanctuary. Even as the first glimmer of collecting water starts shining through the thick patches of grass, the Open-billed Stork *(Anastomus oscitans)* takes possession of the top of the Babul tree. This grayish-white bird with black underparts to the wings is easily

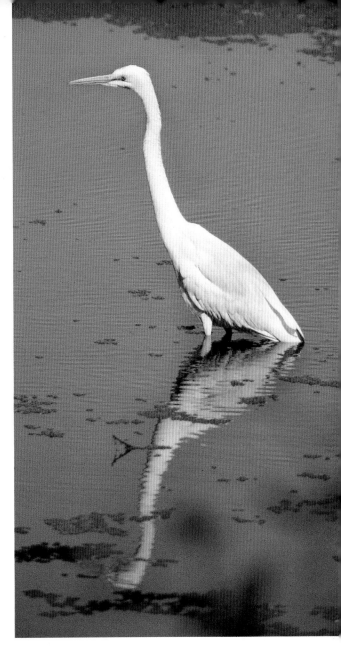

Though it does not nest in the park as much as other egrets, the Great Egret is the most graceful breeding bird here.

distinguished by the gap in its peculiar beak created by the arching mandibles. It starts breeding activities before all the other birds. Immediately after occupying the top branches of the trees, the male starts courting the female. By the end of the second week of July, at the very onset of the monsoon, more than one thousand Open-billed Storks have made their nests on the Babul trees and are awaiting the rain. If rain is late or water not released from Ajan Dam in the month of July, these birds will abandon the nests and may even fly away from the Park. Later, if the lakes are full they may return to the trees to nest.

The birds select four to six sites for their nests. Nest areas are called heronries and there is little variation in their location from year to year. This is probably because of availability of water. Trees near the Canal

where water from Ajan Dam reaches as soon as it is released, are the first choice for nesting sites. Then comes Sapan Mori and Bakalia area. The area behind Shanti Kothi is also a favoured site that gets waterlogged well in time. As soon as the rains start, nesting begins. By the third week of July, eggs can be seen in the nests of the Open-billed Storks. Each female the Gambhiri and the Banganga rivers fill the Ajan Dam almost to the brim. In the first week of August, the sluice gates of the dam are opened and water rushes down the canals. Within 5-7 days, the water spreads over an area of approximately eight sq. km. Once the lake starts filling up, thousands of egrets, cormorants, darters, ibises, herons busy themselves with nest

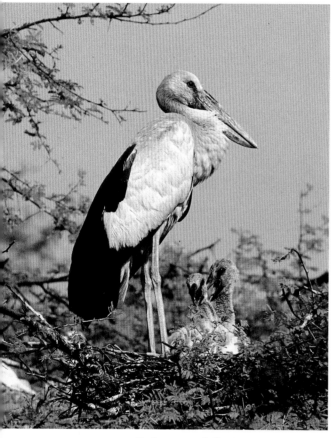

(Below) Open-billed storks, which get their name for the gep between their arched medibles, are the first to nest.

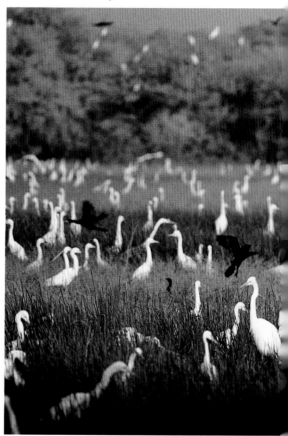

(Above Right) Egrets and other breeding birds feeding in the marsh.

normally lays 3-4 dull white eggs. During this period, the birds feed in the marshlands, well away from the nests, on mollusks, snails, frogs and insects. The storks leave their dwellings by October, when their young ones are in wings.

With these thousands of nests, Keoladeo is transformed into a breeding paradise of the resident water birds. By the end of July,

building, courting and mating.

Cormorants, egrets and darters start making their nests in the lower branches of Babul trees on which the Open-billed Storks are already nesting. Darters and cormorants make their nests in the higher branches of these trees as compared to egrets. The trees are now laden with the primarily black and white birds and all around can be heard

their gurgling, burping and bubbling calls interspersed with beak clappings.

In the early stage of courtship, the Great Egrets *(Casmerodius Albus)* their in, breeding plumage, are full of splendour. During the monsoon, they all develop long ornamental breeding plumes, which the males display to attract the females. All the egrets, except the Cattle Egrets are white. It is the arrangement of their plumes and colours of their faces and legs that is used to differentiate the species. Egrets are usually found in flocks and unless one has seen them fighting for nesting space on trees, it is difficult believe that such a beautiful bird can be so quarrelsome

Intermediate or Median Egrets *(Mesophoyx intermedia)* have plumes on their throat and back. During the breeding phase, the iris of the male bird appears a dark orange red compared to female's orange. The facial and orbital skins of both sexes are lemon yellow with a greenish tinge on the area immediately in front of the eye. There is more green in the female's facial skin than in that of the male. Their beaks are black. Every year, more than thousand Median Egrets breed in the park. They make their nests in the inner part of the tree. The chick hatches after twenty to twenty-two days and is fed regurgitated fish.

Little Egrets *(Egretta garzetta)* come next in the order of breeding. Courting amongst these egrets is charecterised by much bowing, with plumes erect. Their facial and orbital skin turns coral pink. After the dis-

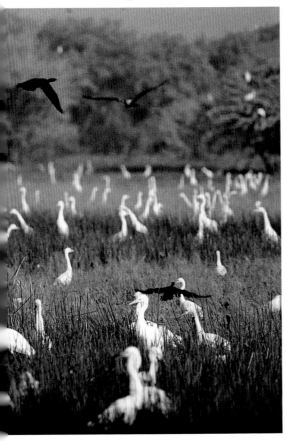

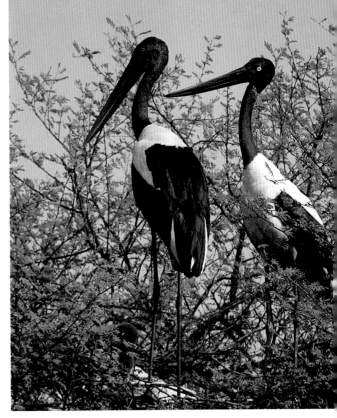

The yellow iris of the female Black-necked stork distisnguishes it from the dark-brown eyed male. The number of these magnificent birds breeding here is dropping every year.

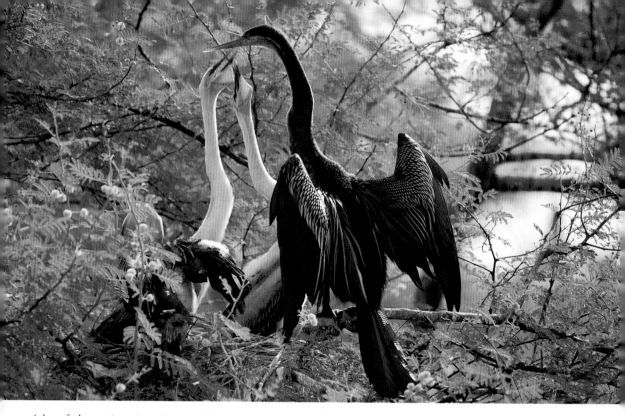

A darter feeding its chicks which are downy white, whereas the parents are black.

play, the colour of the skin returns to the normal pale gray. During these days, their feet are a shining yellow, as if nature has give them yellow socks to enhance their beauty. Their eggs, laid on a simple platform of twigs, are green to start with but fade gradually. Both parents share brooding responsibility. The nestlings have little feathers in the first week and grow rapidly on food regurgitated by their parents.

The Great Egret is relatively uncommon breeding bird, found in smaller numbers as compared to the Median and Little Egret. Watching these birds display is a pleasure in itself. Typically, it raises its tarsal joints and stretches its neck fully to peck at or grab hold of a branch in front. During this action, the dorsal plumes are raised. The face has a turquoise colour while the upper parts of the legs are carmine. Generally, only one or two nests are found on one tree. These are located on the upper branches so that this big bird can alight and take off easily.

The Cattle Egret *(Bubulcus ibis)* resembles the Little Egret. The distinctive feature in the non-breeding season is its the yellow-bill. When breeding the Cattle Egret does not have long plumes but extra colours to add to its finery. The head, neck and back glows an orange gold and the facial skin and eyes become blood red during courtship. In Keoladeo, its nest is usually built in the lower parts of Babul trees and appears to be a very untidy structure of twigs. By the first week of August, the eggs have been laid. A normal clutch has about three to five eggs, of a pale skimmed-milk colour. Both the male and female brood, alternatively incubating the eggs for 17 to 22 days, round the clock. When they hatch and the small cream-coloured young ones have emerged, the empty shells are dropped over the side of the nest by the adults. Egrets

start feeding in the early morning, often more than four to five hundred at one place. They follow the fish in flight and as soon as a fish comes within reach, they start snapping at the surface. In September, when lilies start blooming in the lake, the community feeding of egrets is a spectacular sight.

The Oriental Darter *(Anhinga Melanogaster)*, Great Cormorant *(Phalacrocorax carbo)*, Little Cormorant *(Phalacrocorax niger)*, Indian Shag *(Phalacrocorax fuscicollis)*, and Black-headed Ibis *(Threskiorias melanocephalus)*, also build their nests on Babul trees usually as untidy stick platforms. The only Indian representative of family *Anhingidae*, the darter is a black water bird easily recognised

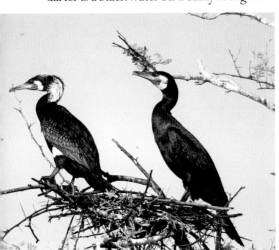

by its slender snake-like velvety brown neck, narrow head and pointed dagger bill. Silver streaks on its black back enhance its beauty. While swimming it looks so much like a snake that it is also called the snakebird. The darter is an expert diver and feeds on fish. Although it spends most of its time in water, its plumage, strangely enough, is not waterproof. It gets soaked and bedraggled after being in the water and needs to dry its feathers in order to maintain its efficiency. Darters nest in groups. Usually four to five nests will be spaced at a distance of one to two feet. The chicks are downy-white when they hatch. The colour gradually changes to light brown as they grow older. By the time they start flying they are already dark brown.

Cormorants are also black birds and their young ones are black from the moment they hatch. The Great Cormorant, a glossy black bird, is the largest of the three cormorants that breed in Bharatpur. It is about as large as a domestic duck with grayish-white on the head and neck during the breeding season when adult breeding birds also develop distinctive white patches on the thighs. Breeding activity starts in the

month of August. The nest is an untidy platform usually placed on the higher branches of a Babul tree. Cormorant chicks are bald when hatched but they soon develop hairy feathers.

Little Cormorants have a small white patch on the throat and a crest on the back of the head. The Indian Cormorant could easily be confused with these two. In the breeding season, however, it has tuft of

(Above) Sitting motionless on a branch the Pond Heron is often very difficult to spot.

(Above Left) Great Comorants prefer to nest on hte highest branches of the Acacia tree.

white feathers behind the eyes and some white speckles on the head and neck. Cormorants feed together in large numbers, co-operating with one another. They dive into the water in tandem and literally herd the fish into a corner before they start feeding on them.

The Black-headed Ibis is a white bird with black bill and legs. It can be recognised by its long, slender, down-curved, curlew-like bill. During breeding season, an attractive red colour appears on the inner side of its wings, which is very conspicuous. It prefers to nest in pure colonies, initiating breeding activities with the beginning of the rains. Each nest has about two to four eggs.

Herons, easily recognised from a distance because of their long, slender, S-shaped necks, also nest in these colonies. During breeding season, the Grey Heron (*Ardea cinerea*) develops a bright orange-red beak, orange-yellow legs, and a black occipital crest. Similarly, the Purple Heron (*Ardea purpuea*), normally a grayish-coloured bird, becomes brighter during breeding season. Both these herons have a liking for grassy, aquatic patches. The Grey Heron nests with other water birds, the Purple Heron makes its nests separately and does not like the intrusion of other water birds.

The comparatively smaller, but beautiful Black-Crowned Night Heron (*Nycticorax nycticorax*) also begins breeding in this season. Developing a long crest on its head and eyes of a deeper red than normal. It nests in the company of other water birds but prefers the comparatively dense growth at the center of the tree. The Pond Heron (*Ardeola grayii*), also called the paddy-bird is an earthy brown bird that is often seen sitting on Babul twigs at the waters edge. If anybody comes close, it flies away, flashing

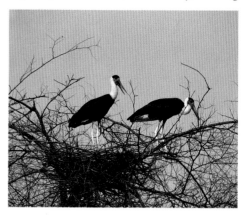

(Above Right)
A pair of White-necked Stork on the nest.

(Right)
White Ibises breed in pure colonies

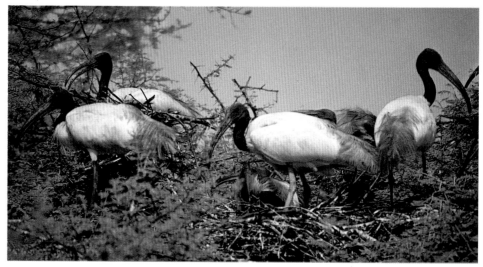

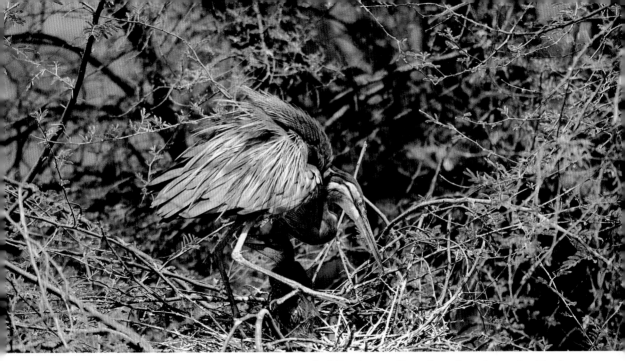

its glistening white wings. It is also seen in breeding plumage during rains but mostly breeds in the villages nearby.

Other than the Open-billed Stork, the Park has three other resident species of storks, namely, Painted Stork *(Mucteria leucocephala)*, Black-necked Stork, *(Ephippiorhynchus asiaticu)*, and the White-necked Stork *(Ciconia episcopus)*. The Painted Stork breeds with the other water birds while the Black-necked Stork and White-necked Stork are solitary breeders. Around the third week of August, the Painted Storks, which had been enjoying fishing in shallow waters away from the trees, start hovering around the trees.

Though the Painted Storks have no special breeding plumage, the new arrivals are specially colourful and bright. The black band across the breast and striking, delicate rose pink feathers near the tail combine with its white colour to enrich its beauty. Both male and female share the work of nest making. The male brings twigs from other Babul trees to the female waiting near the nest, which is a large platform of sticks with a shallow, central depression lined with stems and leaves of water reeds and grass.

During the last week of August and early September, more Painted Storks arrive. Eventually, if conditions for breeding are favourable, about two to three thousand birds busy themselves with constructing nests. Once breeding begins the pair constantly groom each other. At times, a bird can be seen standing blissfully, with

(Above)
A Purple Heron displays its breeding colours.

(Below)
Grey Heron with its young. Chicks are fed in the nest and surrounding branches for about two months.

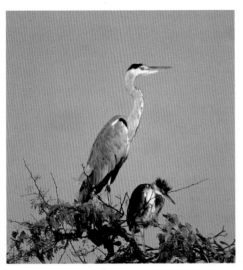

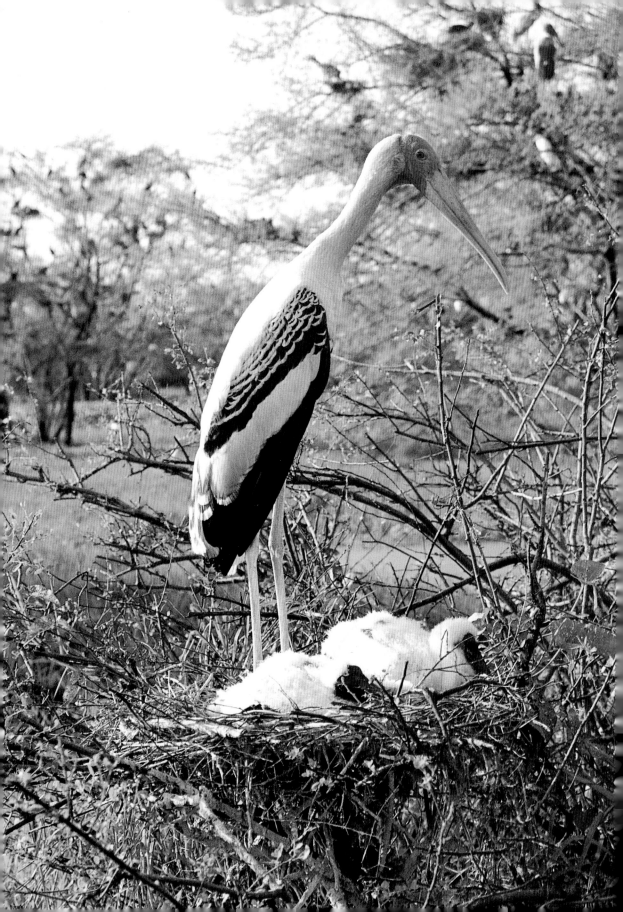

eyes closed, while its partner grooms it. After the grooming session, some pairs will clatter their beaks individually as well as one against each other to produce a unique sound. The bird is otherwise voiceless though the chicks manage to cry out for food as the adult bird reaches the nest with fish in its gullet. The Painted Storks are affectionate and dedicated to their chicks. The parent birds will occasionally shade them from the heat of the sun by spreading their wings.

Eurasian Spoonbills (*Platalea leucorodia*) are late breeders in comparison to other birds. The bill that gives this bird its name is distinctive – black and yellow in colour, it is broad and flat and ends in a widened spatula. In this season, the spoonbills' cream colour turns white, and it puts on the shaggy crest of the breeding plumage. Although both male and female spoonbills develop a crest, that of the male is slightly bigger and heavier than that of the female. Apart from this, a red spot appears on the lower neck of both birds, just below the bill. In males, this spot is darker and brighter. The light yellow spot on the male's bill also becomes more prominent.

By the time they decide to nest, the Babul trees are already laden with nests and the Spoonbills have to compromise with the space left. Their nests are also pile of dry twigs but lined with grass. When the chicks hatch, parent birds have a full-time task feeding them. The chicks force their beaks into the adult's bill and extract their food. Newly hatched chicks have a straight bill which gradually develops the spoon-like shape.

After mid-September, young ones are visible in the nests of Painted Storks as well as the spoonbills. Not much activity is witnessed while they are very young, but as they grow, they start demanding more food from their parents. Researches have revealed that over a thousand Painted Storks alone consume about 2000 kg. of fish and other aquatic animals. This gives an idea of the quantity of food required by the over 15,000 birds of different species that breed

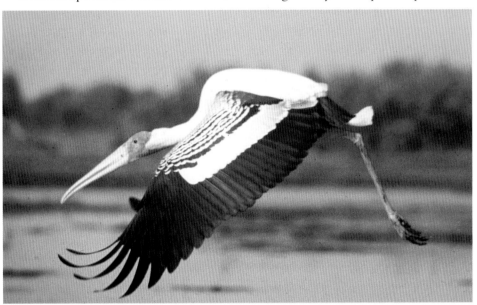

Painted Stork in flight. These birds develop a dazzling pink color on the back as breeding plumag

(Opposite page) Painted Stork with chick. The newborn are bald but are soon covered with woolly hair-like feathers.

(Right)
The breeding plume of the Egret is a distrctwc orange.

(Bottom)
Painted Storks squabble over the best nesting sites on an Acacia tree.

(Facing page)
Little Cormorant with young ones.

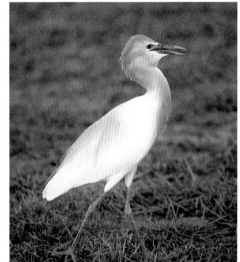

in the Park. The fact that Keoladeo Lake provides this is what attracts such a large breeding population here.

Black-necked Storks also start breeding in the month of September-October, black and white. These birds are easily recognised by their coral legs. The female can be identified by its yellow eyes. They usually live in pairs making their nests atop a high Kadam, Babul or Peepal tree. Three to five eggs are laid and by January-February chicks grow up and leave their nests. The White-necked Stork is a glossy bird with sprinkling of purple or greenish-blue—a conspicuous white neck and black crown. It is a solitary nester and makes its nest away from other breeders on the higher branches of trees much like the Black-necked Stork. In the Park, it can be seen on the banks of water bodies, in pairs or single.

By the end of October, all the chicks except those of Painted Storks and Spoonbills have grown up and started flying. By end of November, the young Spoonbills have also grown up. It is the chicks of the late-breeding Painted Stork that are still being looked after by their parents well into the last week of December and sometimes even in the month of January-February.

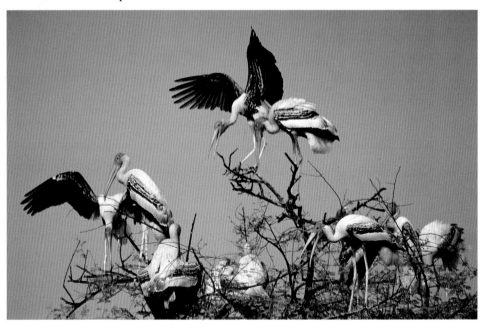

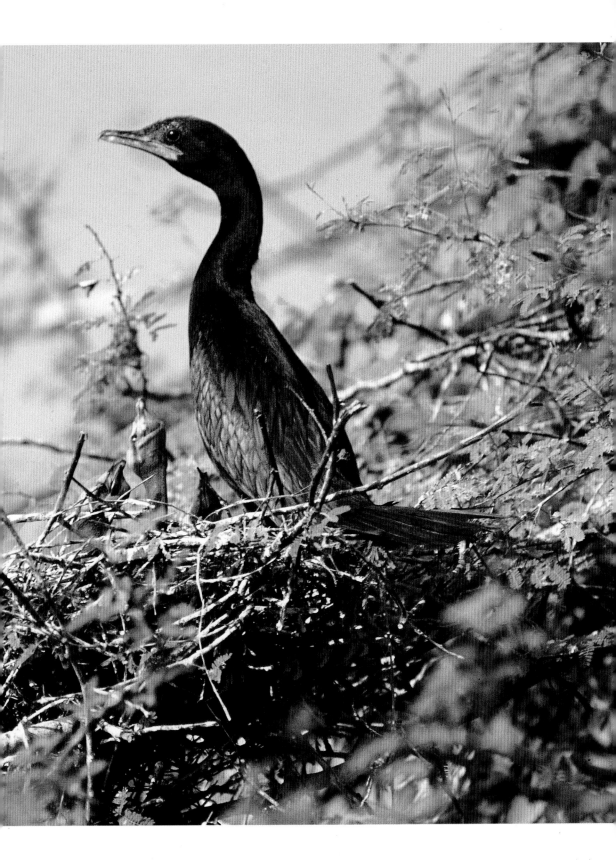

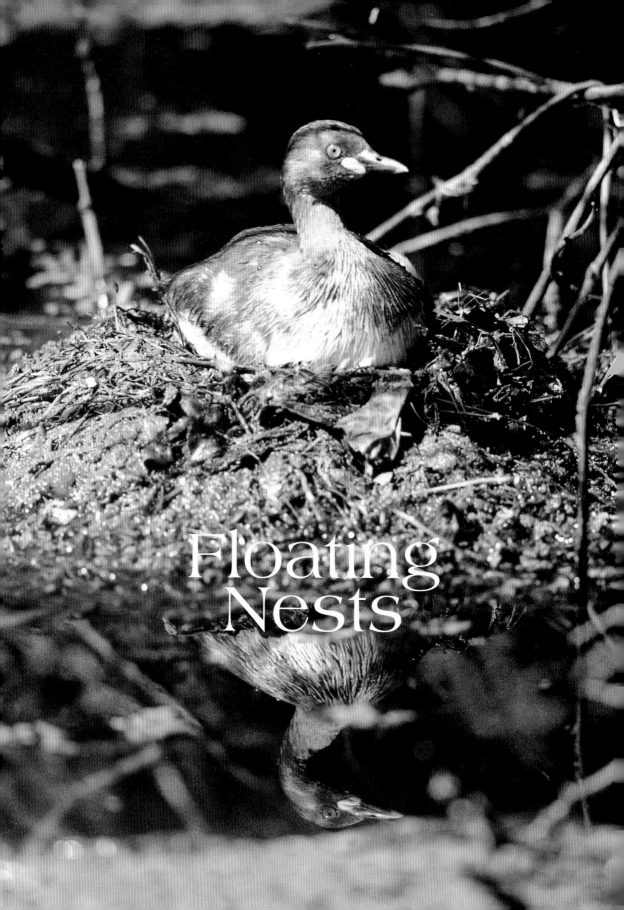
Floating Nests

With the arrival of more water from Ajan Dam the aquatic vegetation in Ghana starts spreading fast. Once is this lush and green, floating nest-making such as birds the Bronze-winged Jacana *(Metopidius indicus)*, and the Pheasant-tailed Jacana *(Hydrophasianus chirurgus)*, become active. In both these species the female is polyandrous. She mates, lays her eggs and leaves them to be hatched and the young ones cared for by the male, while she finds another mate. Thus, a female may have three or four affairs and broods during one breeding season.

The metallic-green Bronze-winged Jacana that runs around on the floating vegetation is a conspicuous bird. In this species, the female is bigger than the male. The population of these birds increases suddenly with the onset of monsoon and peaks between July and November. This coincides with their breeding season which starts during the rains. A shrill wheezing *Seek Seek Seek* coming out of the high grass is an indication that the bird is busy pairing. After mating, the female normally lays four beautiful bronze eggs, then hands over the nest to the male and flies off in search of another mating partner. It mates with three to four males in one season. Its nest, made in thick floating grass, is a skimpy pad of twisted weed, placed on floating aquatic vegetation, a marvellous example of the birds engineering skills. The floating mass helps keep the nest above water even when water level rises after heavy rain, and it is anchored on all four sides for stability even in flowing water. If at any stage, the nest is found to be unsuitable or unsafe, it is the male who takes the eggs in his beak to another nest built by him.

The eggs, laid on the floating platform are exquisite; so glossy that they seem permanently wet, and covered by black lines that suggest inscriptions by a master

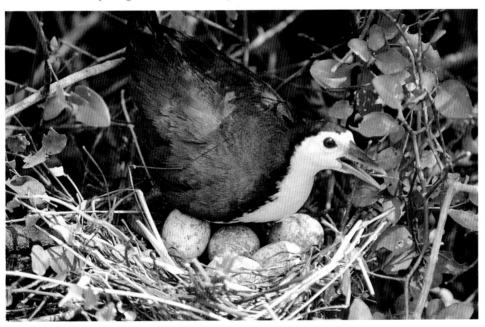

White-breasted Waterhen incubating the eggs. Nests are made above the water-line on any suitable branch. Male and female both share the incubation.

(Facing page) Little Grebe on its nest. This floating platform is made of twigs and reeds.

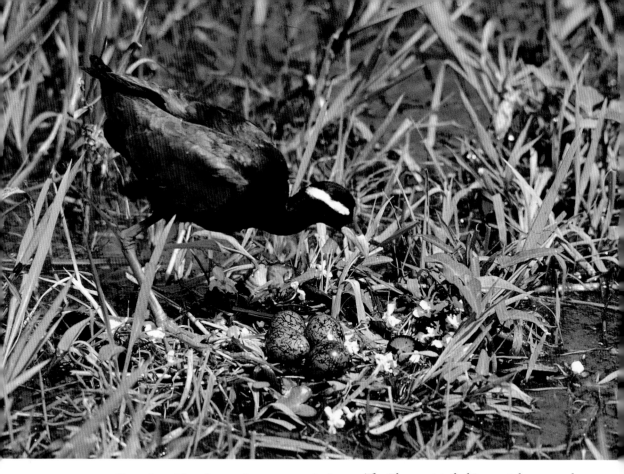

calligrapher. After the incubation period of 25 to 27 days, the eggs hatch. The male watches carefully, and as soon as the chick comes out of the egg, the parent bird covers it with its wings. The young ones remain in the nest for four to six hours, after which the male leaves the nest with the fledglings tucked neatly under his wings.

The Pheasant-tailed Jacana is brown and white with a golden velvet neck and has a long, elegantly curved tail. The female lays her four olive brown eggs on the floating leaves of the lily or in a depression in a mound of vegetation in the open water. Together the nest and the bird are always lighter than the water displaced by the big lily leaves. The male, who incubates the eggs, always repairs the nest. Even though the nest is made in open water, it is so perfectly camouflaged that no harrier or other bird is able to discover the eggs. Bird watchers keep vigilant eyes on the Jacana in an attempt to discover the eggs or nest, but they rarely succeed. Even when the bird leaves the nest, it still keeps an eye on it. When returning, it lands a good 10 meters away, then strolls towards the nest picking

up some food or nesting material. It will stay away till sure there no danger to the nest.

The Purple Moorhen *(Porphyrio porphyrio)*, which also has a liking for thick aquatic vegetation near open water, also breeds in September and October. The bird can be identified quite easily because of its purplish-blue colour, bold red forehead and long bare red legs. The birds are very noisy during their breeding season. The male goes through a ludicrous courtship display, holding water-reeds in his bill while bowing to the female to the accompaniment of loud chuckles. Its nest is a shallow depression on a mound of grass or sedge. The normal clutch consists of four to five, cream to reddish-buff coloured eggs, which hatch after 26-27 days of incubation. In a good season, more than 80 pairs of Purple Moorhen breed in the Park. During the rains the number these birds is low but, as winter approaches, it starts increasing. The Indian Moorhen *(Gallinula chloropus)*, also breeds in the Park. It makes a loosely woven reed nest in the thick grass vegetation on the swampy edges of lake.

The Dabchick *(Tachyvkptus ruficollis)* or Little Grebe is a smaller, dark brown bird with white underparts, only six inches long, with a short neck and no tail. Normally seen in small groups, the bird turns solitary during breeding, violently defending its territory against rivals. *Wit-wit-wit-wit*, the alarm call of the Little Grebe can be heard from a distance. These birds make their floating nests in the thick cover of aquatic vegetation on the lake, though they may also nest on a mound with open water all around. The eggs hatch in 18 to 22 days after which the female may start another nest, leaving the male to look after the chicks.

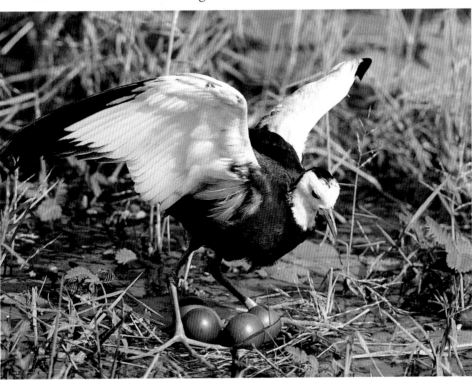

Both the Phaesant-tailed Jacana (left) and the Bronze-winged Jacana (facing page above) make nests that float on water.

(Facing page bottom) A pair of Purple Moorhen on hte water's edge.

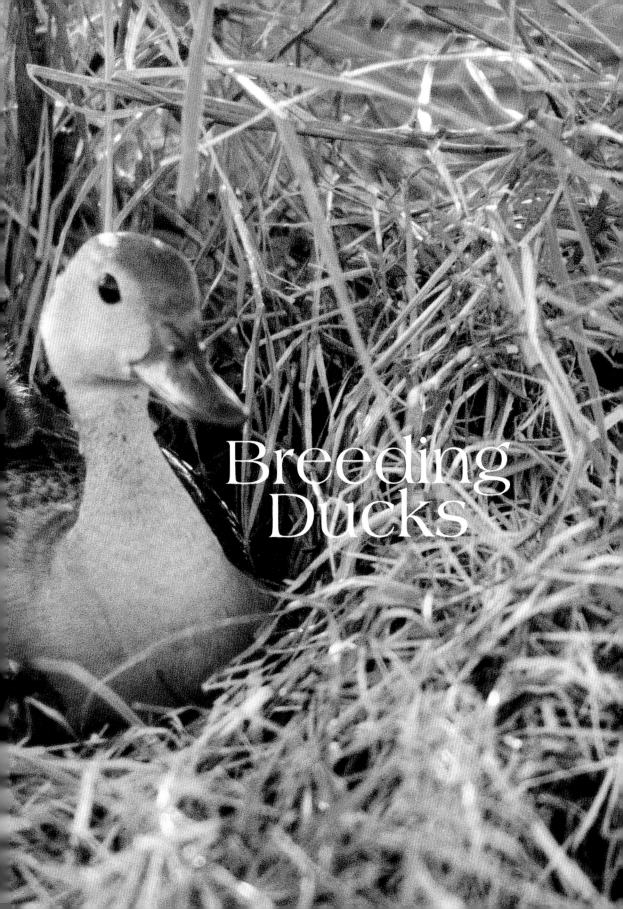

Four species of ducks breed in the Park. Of them, the most well known is the Spotbill (*Anas poecilorhyncha*) – a large mottled brown duck which, because of its gray-brown colour, is also known as the Gray Duck. It is usually seen in pairs but, sometimes, also in small flocks of own species near open water. Its dark bill has a yellow tip, though it is called Spotbill because of two orange-red spots on the base of the bill. The bird has been found breeding almost throughout the year in different parts of the country. In Bharatpur, it breeds from July to September. Nests in are made in grass and mounds of grass and other vegetation, where it lays about eight to nine greenish-white eggs. Usually a silent bird,

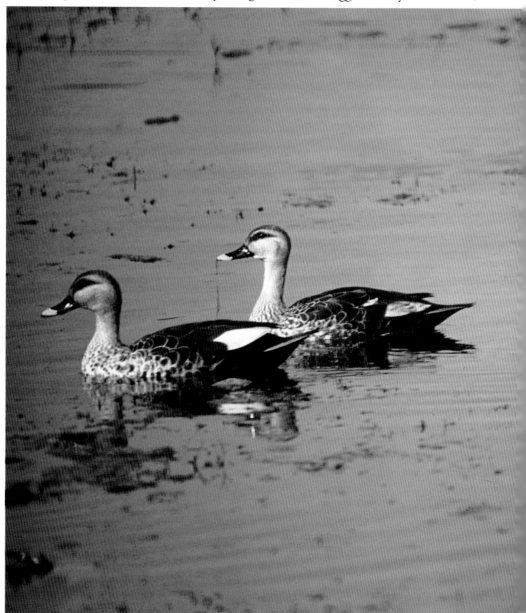

it becomes very vocal during breeding time and if another male ventures near its nest it is quickly chased away. It can be seen in open water and mainly feed on aquatic plants and seeds.

The Cotton Pygmy Goose *(Nettapus coromandelianus)*, is the smallest duck of the Park. Slightly larger than a pigeon, it is largely black and white in colour.

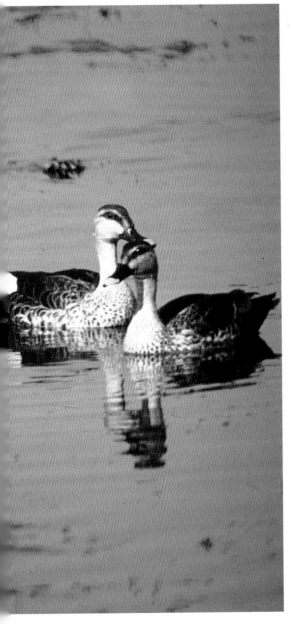

Its preferred habitat is open water with floating vegetation. Cotton Teals make their nests in a hollow of a tree and incubate the eggs to successfully bring up the young ones from the tree nest. In September, the bird can be seen in the area of Bakalia and Sapan Mori with six to ten small ducklings. The Cotton Teal prefers feeding on Hydrilla and Spirolela.

Nakta or the Comb Duck *(Sarkidiornis melanotos)*, is a large, glistening blue-black and white bird, the male of which is distinguished by a knob on its bill. The growth of this 'comb' or knob on the bill of the male during breeding season is peculiar to the species. The female is knobless and lays its eggs in a tree hollow, well above water level. At Bharatpur, the Comb Duck mostly feeds outside the Park.

Found in the large, water lily-covered lakes is the Lesser Whistling Teal *(Dendrocygna javanica),* also called Tree Duck, a chestnut coloured bird with a long neck and upright posture. It is smaller than the Spoonbill and is famous for its shrill whistle, heard usually in flight. Found in large groups of 50-60 birds, the flock takes flight one after the other when disturbed. In winter, one can see flocks of them in the Bakalaya area. Four or five nests of this species can be seen every year during the monsoon, usually in shrubs near the water, but I once saw its brown eggs in the hollow of a Babul tree, about 6 feet above the ground. Observations have revealed that the eggs are milky white in the beginning but they turn brownish when the duck starts incubating them. The ducklings are smaller than that of a hen and hairy, with black and white strips.

Easily identified by the praminent red spots on the base of the bill as well as the yellow tip, Spot bills are usually seen in pairs in open water.

(Previous page) The Lesser Whistling Teal derives its name from the sibilant, double-noted call.

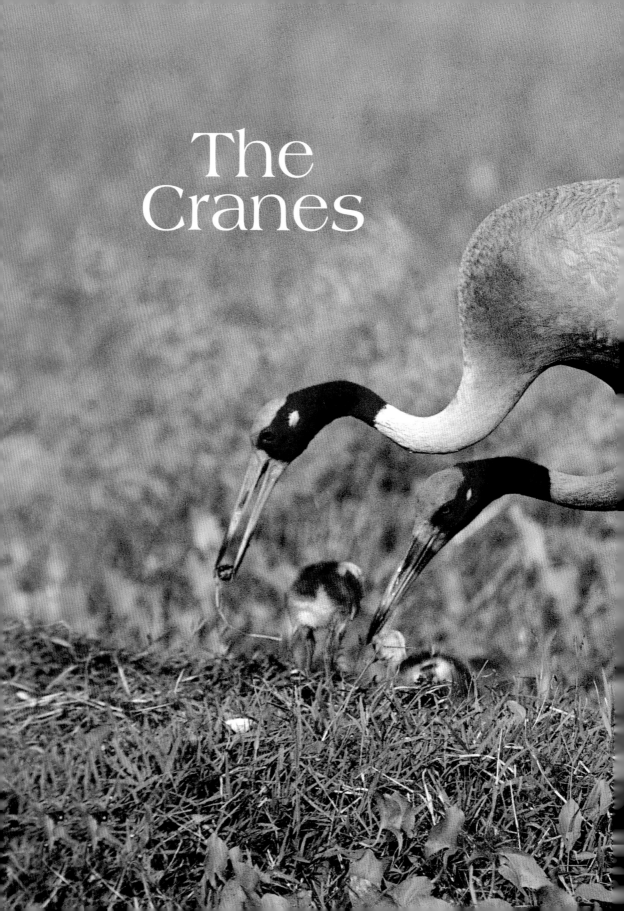
The Cranes

With water over-flowing from Ajan Dam, the tallest of the Indian wading birds, the Saras Crane *(Grus Antigone)*, also starts nesting. Light gray in colour with a red head and gray forehead, a Saras stands about five feet tall. An adult bird probably weighs about 7.73 Kgs. The most remarkable characteristic of the Saras Crane is fidelity. Once a pair is formed, it stays together for years. The courtship dance of the Saras Crane is an unforgettable sight. The male and the female greet each other with bowed heads. The female then points her beak to the sky and trumpets. The male responds immediately with a more sedate, though shriller trumpet. Bowing and half-spreading his wings, the he continues in a slow cadence – *preow, preow, preow.* Calling in unison, the pair proclaims firm possession of territory. The main breeding season of Saras Cranes in the Park is from August to October. They also, though in smaller numbers, breed in February to March when the marshland begins to dry. However, in this season, the nests adn vulnerable and breedingless successful.

In the seventies, the number of Saras Cranes in the Sanctuary was more than one thousand. But during the nineties, the number dropped drastically and now only around two hundred birds arrive here. The breeding population of Saras in the Park is also decreasing, a cause for worry for ornithologists. 27 pairs bred in 1969, which gradually reduced to 16 in 1980 and dropped to only 4 in 1984. Fortunately, it increased to 11 in 1985 but breeding pairs are decreasing year after year. There were seven pairs that bred in 2001 and only five

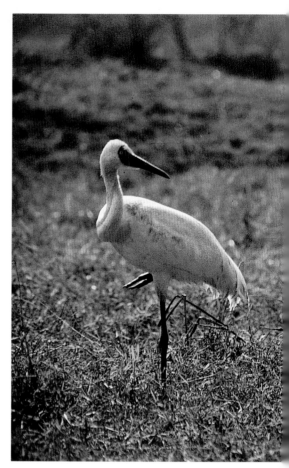

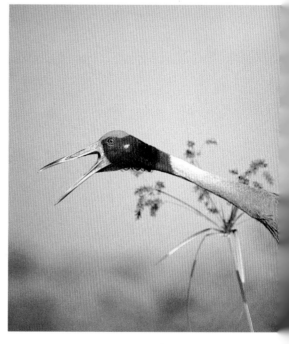

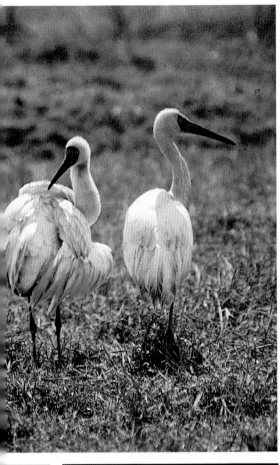

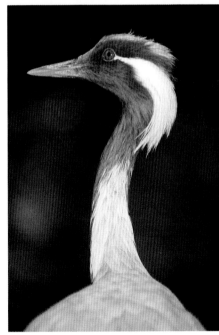

in 2003.

The Saras Crane makes its nest in the lake, where marsh and woodland meet. Generally, the nest is built on slightly raised area surrounded by water. The birds pluck grass and other small plants and pile them up to form a rough mound. The nesting materials include *Acacia nilotica, Paspalum disticum, Ipomea aquatica,* etc. Both sexes participate in the building of the nest. They do not carry the material to the nest but collect it from the site and put it in place with a lateral movement of the beak. The Saras is a lonely nester.

Only two eggs are bird, at an interval of two to three days. Both the male and female incubate alternately. Usually, one partner sits in the nest for two to three hours before getting up to greet the other who is walking slowly up to the nest. For a few moments both of them dance and trumpet in shrill voices that can be heard for over a kilometer. The relieved partner then flies off to feed leaving charge of the nest to the other bird, which arranges and rearranges the two eggs and prepares itself for a long sitting. The young ones hatch in about 32 days. The newly born are about six inches in length but they grow at the rate of 2 to 2.5 cm per day and soon attain the size of the parent.

There are only 10 to 14 pairs of Saras in the Park during winter, but the population grows to more than a 100 towards the end of March when birds from neighbouring areas flock here in large numbers. During these days, the birds begin to arrive at about four in the evening. Some even arrive after dark but most of these leave again at sunrise.

At this time, the lakes of Ghana are almost dry. The Saras usually feeds all day in small ponds. It relishes the *Scirpus*

(Above)
Rare and endangered Siberian Cranes. Keoladeo is the only site in India for these cranes.

(Botom left)
Saras Crane is the tallest flying bird in the world. It's loud trumpeting call can be heard up to 1 to 2 kms.

(Bottom right)
Demoiselle crane

(Previous page)
A pair of Saras Crane with their newly borne chicks. After 30-32 days of hatching golden color chicks are born.

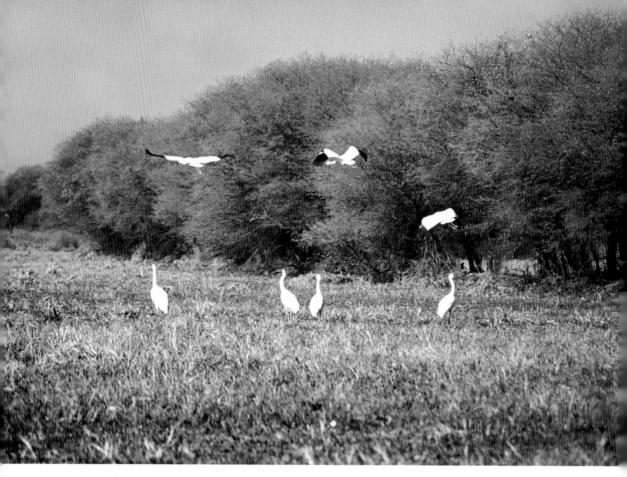

tuberosus and *Eleochais plantaginea* grass of the Park but also likes to eat mollusks, snakes, insects, fish, frogs, etc.

By the last week of October, migratory water fowl, shore birds and many others have streamed into the Park. The clamour of their voices heralds a new season. This is the time when the Siberian Crane *(Grus Leucogeranus)* enters the Park for the winter, calming the anxiety of Park officials and other bird lovers. The whole Park is filled with peculiar kind of joy and bird lovers rush to have the first glance at these rare birds, which usually land near Kadam Kunj area, and sometimes behind Keoladeo temple and the Sapan Mori area.

The Siberian Cranes stay in the shallow waters of the Park. Usually, a young one accompanies a pair. These immature birds can be identified from a distance by their chestnut colour. Adults are white with a pink bill and legs. Black tips to the wings are clearly visible while they fly or preen. In the cool of the morning, even before the sun has given any of its warmth, these snowy birds are in the air, calling softly as they fly to their feeding grounds in another marsh. The cranes mainly feed on rhizomes and tubers of *Cyperus rotundus, Scirpus littoralis, Scirpus tuberosus* and *Nymphea,* though they enjoy insects and mollusks too.

Like the Saras, the Siberian Cranes also usually live in pairs. Within five to seven days of coming to the Park, every pair has selected its territory, which it defends against other cranes. In the early hours of morning, above the nasal babbling and honking of ducks and geese can be heard

clear, flute like notes – *dee-dum, dee-dum*. This is the call of the Siberian Crane defending its territory. Normally not a territorial bird, once it has settled in a particular area, it will resist intrusion, proclaiming ownership of the territory mostly by call.

Siberian Cranes have been coming to the lakes and wetlands of northern India for the last so many centuries. Even the early paintings by Ustad Mansoor, the famous seventeenth century painter in the Mughal Court of Jahangir, show Siberian Cranes. Nineteenth century naturalists called it the 'Snow Wreath' and 'Lily of the Birds', a romantic aura they bestowed on few other species. In the 1880's ornithologists estimated that about 2,000 Siberian cranes wintered in India each year. The birds were then seen in a dozen different regions. The famous bird expert, Dr. Salim Ali also saw these birds in Prayagpur Lake in the Bahraich District of Uttar Pradesh. Unfortunately, pressure of human population has converted wetlands into farms and considerably reduced the spread of these birds. Consequently, over the years, the migration of Siberian Cranes has been limited to this Park only and here too, their population is decreasing rapidly.

In the winter of 1964-65, over 200 Siberian Cranes wintered in Keoladeo Lake but the numbers dwindled. Only 76 cranes arrived in 1970, 33 in 1979, rising to 41 in 1984. The sharp drop in 1979 could have been due to drought, but naturalists have cause to worry. Research reveals that the harsh, cold climate of Siberia checks successful breeding. In any case, even in Siberia, breeding grounds are now confined to north-eastern Yakutia, between the Yana and Kely rivers and to the lower reaches of the Ob River. The Cranes from the Ob River winter as far west as the Caspian Sea coast and Asia Minor as well as in various locations in Iran and India. However, a drastic revision was made a few years ago when some 2000 birds were found wintering on the Pyongyang Lake in the Yangtse Valley of China.

The flocks coming to Keoladeo, a journey approximately 5500 km in each direction every year, have to survive sightings by Afghan tribals and Pakistani Mujahid who are particularly fond of crane meat. For this reason even rest stops on the lakes in these countries become hazardous for the birds. This is another reason for the decrease in population.

Worried by the decreasing numbers,

(Below) Sraus Cranes. The unique unison call of these cranes is a ritual perfomence.

(Facing page) A flock of Siberian Cranes

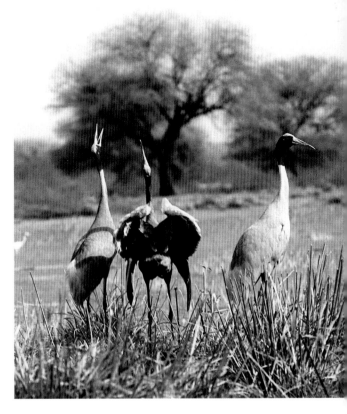

Common Cranes. These cranes prefer relatively drier parts of the Park

Park officials and bird watchers appealed to the Government to take positive measures to protect these magnificent cranes. In 1993 with the help of the International Crane Foundation, the Government of India started a captive-breeding programme. The International Crane Foundation has set up a species bank at Wisconsin, United States of America.

To ensure the success of the conservation and captive-breeding programme, in 1993 a memorandum was signed by five range States – India, The Islamic Republic of Iran, Kazakistan, Pakistan and Russian Federation. The agreement also aims to help save the Central and Western Asian population of this highly endangered species. After a meeting of officials from the five range States, an action plan to conserve and increase population of Siberian Cranes was prepared and it was decided to release all captive Siberian Cranes in Keoladeo National Park to augment the wild population. It was also decided to capture Common Cranes and harness radio transmitters on them to study local movements in Keoladev National Park. Thirdly, it was decided to capture Common as well as Siberian Cranes and deploy satellite transmitters on them so as to study their migratory route to breeding grounds.

According to the plan, two juvenile Siberian Cranes bred in captivity named White and Bugle were brought to the Park in the winter of 1992-93. The idea was to use the wild Siberian Cranes to guide for these captive-bred ones on the return migration to their natural breeding grounds. That year only five Siberian Cranes visited the Park. White and Bugle did not get much time to mix with these wild cranes, which

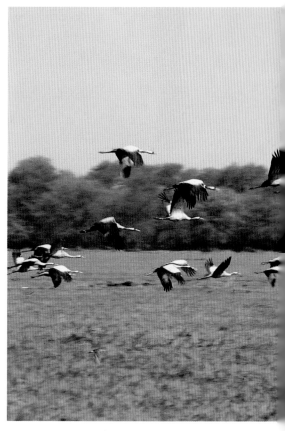

were about to make their move to the Kunovat River Basin in Siberia. They failed to migrate with the wild Cranes and were immediately shifted to Jaipur Zoo.

In the early winter of 1993-94, four more human-reared juveniles, Boris and Gorby from the International Crane Foundation, and Billy and Bushy from Russia were brought to Bharatpur to join White and Bugle who had been brought back from Jaipur Zoo. They formed a close bond among themselves and were often seen feeding and flying with each other. Park officials also observed their association with the Common as well as Sarus cranes leading then to hope that they could fly back to Siberia with the wild migrants. Unfortunately, that year wild Siberian Cranes did not come to the Park. The

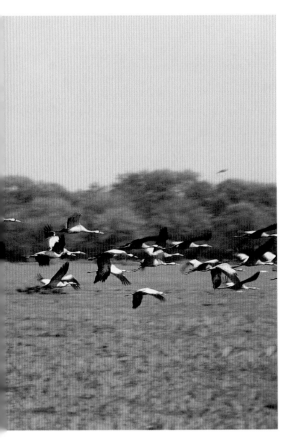

captive juveniles were not able to go to Siberia. A survey was conducted and experts went to different sites to see if the cranes had landed in other wetlands. However, they were disappointed.

In March 1994, White and Bugle were kept in the Park to study their behaviour, habitat utilisation, movement pattern and adaptation to the semi-arid climatic conditions, while the other four juveniles were shifted to Jaipur Zoo.

Both White and Bugle adapted themselves superbly to the summer in the Park, but, unfortunately, White was killed in a territorial fight with a Black-necked Stork. Bugle was shifted to Jaipur Zoo the very next day. That year, Bushy also died in the zoo.

In October 1994, Park officials brought Boris, Bugle, Gorby and Billy to the Park under close observation. The observations included a study of their adaptation to the semi-arid region, home range, habitat utilisation, etc. It was found that these four birds ranged 12-13 km. away from the Park boundary. Then they flew away from the Park. The officials searched for them in nearby wetland areas but they could not be located.

Then a second attempt was made by the Ministry of Environment and Forests, Government of India in January, 1997. Four young captive-reared Siberian Cranes, Behrami, Anabur, Ayafat (all females) and Alkonoft (male) were flown to New Delhi, from where they taken to Bharatpur in a Canter. This time transmitters were attached to them before they were released in the Park on February 01, 1997.

After a two-year absence, on November 16, 1996, three wild Siberian Cranes had reached the Park. They flew back to Siberia at the end of February 1997. Since the interaction between them and the transmitter-fitted birds had been practically nil, the guests returned alone leaving the four behind in Keoladeo. Desperate attempts were made to catch some of the visitors. Expert bird catchers were brought in from Bihar. But all these efforts were in vain. Left behind, a sad Ayafat was found dead in September, 1997. In June 1998, the other three left the Park. Searches were futile. Then on July 17, 1998, Anabur was brought back to the Park by the police. She died a day later. The other two have remained untraced till date.

Besides Siberian Cranes, the relatively larger Common Crane *(Grus grus)* also frequents the drier parts of the Park during

winter. A migrant from northern Europe this gray bird can be identified from a distance because of its black head and neck, and the bare patch of red skin on the crown. The Common Crane generally lives in large flocks on the plains and is a bit difficult to approach. On the alarm call of a single bird, the entire flock will fly away, trumpeting collectively. They spend the morning and evening in the Park, going out in search of vegetation and insects to feed on during the day.

Another visitor to Keoladeo over the winter, though in fewer in numbers, is the small, three feet high, Demoiselle Crane *(Grus Virgo)*, a gray bird with a black face, neck and breast and conspicuous soft, white ear tufts behind the eyes. The black feathers of the lower neck fall in long plumes over its breast, while the tail feathers are less bunched and more drooping than those of other cranes. The whole effect is one of grace and elegance. A striking feature, noticeable at close quarters, is its bright ruby-red eyes. These cranes live in flocks that can be seen flying in a disciplined V formation. The Park is a stopover in their migration to other parts of the country, especially western Rajasthan and Gujarat. They often spend the heat of the day soaring or resting, normally close to the water, visiting neighbouring cultivated lands in the morning and evening, where their depredation of wheat, ground nut and gram fields is considerable.

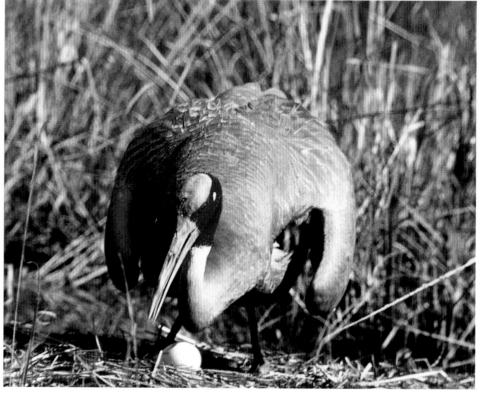

Sarus Crane on its nest. Male and female hatch the eggs and change incubation duties at regular intervals.

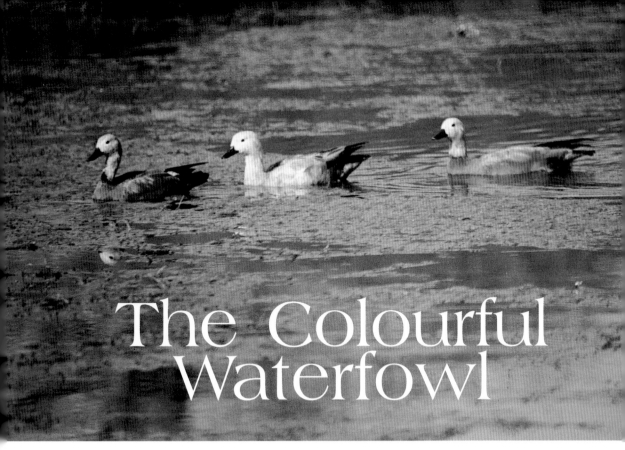

The Colourful Waterfowl

Come August end and Keoladeo is at its best. Plant growth is fresh and green and the bushes lining the shores of the lakes are lush with flowering climbers laden attractive red, pink, white and purple flowers. There are more butterflies, beetles, and dragonflies now than at any other time of the year.

This is also when flocks of Rosy Starling (Stunus roseus) and Common Starlings (Sturnus vulgaris) arrive at Keoladeo from their nesting grounds in eastern Europe. They are accompanied by the first of the waterfowl that will winter in the Park — the Garganey (Anas Querquedela). This small duck heralds thousand upon thousands of migratory waterfowl that come to the Park each winter before returning to their breeding grounds when the weather improves in March-April.

Towards the end of September, it begins to get cooler, especially at night. This is when, in addition to the waterfowl, waders such as the sand pipers, snipes, plovers, stilts, avocets, rails and crakes arrive in increasing numbers. The first influx does not come into the Park. It settles at Ajan Dam. It is by November that the lakes brim over with geese and ducks, giving the early riser the opportunity to witness the morning flight of these birds, surely one of the most exciting sights in nature.

(Above)
A family of Ruddy Shelduck. These ducks are said to pair for life.

(Bottom)
A pair of Red-crested Pochard.

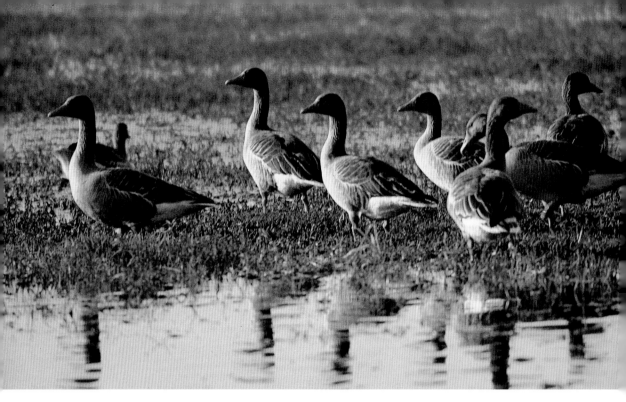

Grey lag Geese are a common site in the park during winters.

(Facing page) Pintail Ducks

Geese prefer to sleep in the safety of aquatic vegetation. At dawn, the steady murmur of the flock increases in volume as the birds become restless in the growing light. The flight usually starts at dawn and takes till just after sunrise. However, at times, when the Park is frosty or misty, the geese may stay up to an hour later on the roost. Most of the geese and ducks head for Ajan Dam and Bandh Baraitha, which are situated near the Park. The evening flight is no less spectacular. The skeins fly high until almost over the roost and then come tumbling out of the sky, emptying the air from their wings in order to lose height rapidly and once down, they bathe, splash and drink before settling for the night.

Different types of geese have many things in common. For instance, their bills, though varying in size and colour, are similar in basic structure. But, the most important and striking of these common characteristics is that geese usually mate for life.

Most commonly sighted in the Park, are the Bar-headed *(Anser indicus)* and Graylag Geese *(Anser anser)*. Apart from these, a third, the White-fronted Goose is also sighted occasionally. The Bar-headed Goose is a gray and white bird distinguished by the presence of two black bars on back of its head and yellow-orange bill and legs. The bird breeds during summer in the Tibet and Laddakh area of the Himalaya as well as in the highlands of Central Asia, at an altitude of at least 14,000 feet or, on islands in marshy lakes and on rocky outcrops along the margins of swamps. As safe nesting areas are limited, the geese nest together in colonies. Some observers have recorded them nesting in trees, but this is rare and occurs only when the water level rises and platforms of drifting vegetation or the nests of other birds become available. They have been known to migrate at 27,000 feet over the Himalaya into northern India. Although

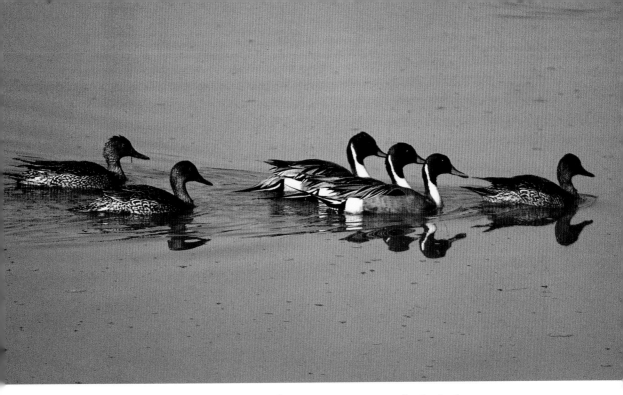

these birds reach northern India around September-October, they come to the Park in November-December, staying here until their return to breeding ground in the month of April. It is these geese that are celebrated in Indian literature as magical birds.

Of the two sub-groups of Graylag Geese, it is the Eastern *(Anser anser rubrirostris)*, which breeds west of the Ural Mountains in Central Russia, that comes to Keoladeo. Easily identified by its pink beak and legs, the Greylag is usually sighted in groups, particularly on a sunny winter afternoon when they rest in hundreds near the Keoladeo temple. The Graylag's large head and bill stand out in silhouette. In flight, it is distinguished by the pale gray of its forewings. Some adults have small patches of white on the forehead and frequently, black markings on the belly. It has a loud call, which is often trisyllabic, sometimes with extended notes.

Amongst waterfowl, ducks are most prominent and the number of surface feeding and diving ducks that visit the lakes is almost equal. The most characteristic feature of ducks that strikes a casual observer is dimorphism of sexes. The male is usually more brightly coloured and easily recognisable whereas the plumage of the female is dull. In contrast to geese, ducks do not pair for life.

The Pintail *(Anas acuta)* is, perhaps, the most distinctive, elegant and common species of surface feeding ducks that visit the Park. The male's white chest and the white strips that extend on either side of its chocolate-coloured head, its long thin neck and pointed tail stand out whether the bird is on the ground or in the water. The female, like most female dabbling ducks, is brown and dull in appearance. This is not a vocal duck though sometimes it whistles softly. It devours small water insects along with aquatic vegetation. Occasionally, when

feeding, only the pointed tail and body is visible while the bill and neck is in the water. This happens when the bird tries to reach deeper with its bill to feed off the bottom of the lake. The Pintail is an opportunistic bird and will move to a new location the moment there is drop in its feed.

The another common duck, the Wigeon *(Anas penelope)* can be spotted from a distance because of its distinctive chestnut head and a broad buff strip on the crown. In flight, the patch of white on the upper wing is very striking. The Wigeon has a short neck and its bill is ideally suited for grazing. It is also seen eating grass and leaves that float on water. Early morning by the lake one can hear the unforgettable and thrilling sound of the high-pitched *'whee-o'* whistle of this bird in flight.

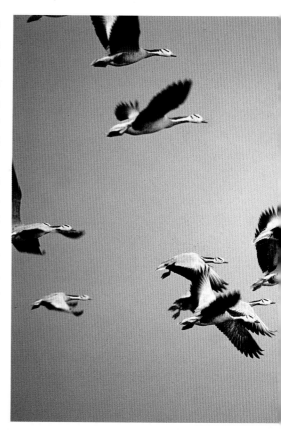

The Gadwall Ducks *(Anas strepera)* can also be seen here in large numbers during winter. The male has gray flanks and brownish-gray back and the bill of female has conspicuous orange edges. The white on its speculum is a good identifying feature in flight. This duck prefers to spend most of its time in water, eating floating vegetation and occasionally diving up ended to the depth of 12 inches to eat aquatic plants. It is also a good walker and may also be seen grazing on land.

The Common Shelduck, *(Tadorna tadorna)* is a rare sight in the Park. Shelducks are links between ducks and geese. Both male and female are similar in colour, though the female is a little smaller. The male has a conspicuous red knob at the base of the bill that differentiates it.

The Ruddy Shelduck *(Tadorna ferruginea)* can be identified from a distance by its

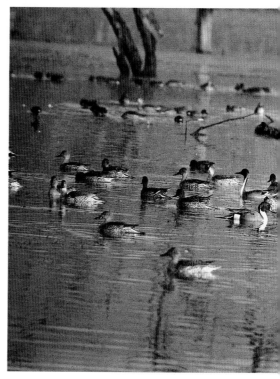

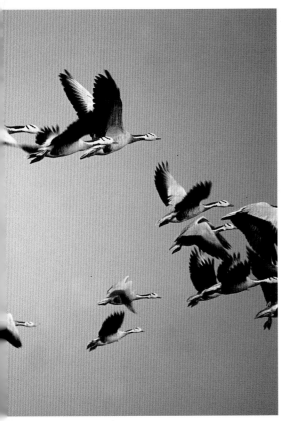

(Above) Bar-headed Geese are known for their powerful and long flight. They breed in Laddhak and migrate over Himalayas.

bright body and black primaries. The male can be differenciated only by the narrow black band around the middle of the neck and the head, which is lighter than the body. The long, stable bonding between pairs has made these ducks a favourite subject for poets in India. They are alert birds, highly suspicious, and are usually among the first to rise, giving a typical alarm call. Naturalists believe that the destruction of breeding grounds in Tibet, Laddakh, Mongolia and Central Asia has lowered the breeding rate of the bird. Definitely, the gradual decrease in the number visiting the Park has worried officials.

Among coloured ducks, the Shoveler's *(Anas clypeata)* bold patterning is very distinct. The male has a white and chestnut body while the female is grayish brown. It is also a common duck in the Park, distinguished from other ducks by the very long spatulate bill. It usually feeds in groups in the open waters of Bakalia and Mansarover, where it can be seen swimming with bill half in and half out of the water. The large bill helps the bird sieve small food particles from the surface of the water, which is why it feeds most often while swimming. Its orange legs and pale grayish-blue forewing are clearly evident in flight.

The Garganey *(Anas querquedula)* is a medium-sized duck. During breeding season, it can be identified from distance by the white stripe above the eyes on the reddish-brown head of the drake. Otherwise, it looks very like the Common Teal. This duck is famous for its long flight. Using the Park as a passage, it migrates to the south and visits again enroute to its breeding grounds in the temperate regions.

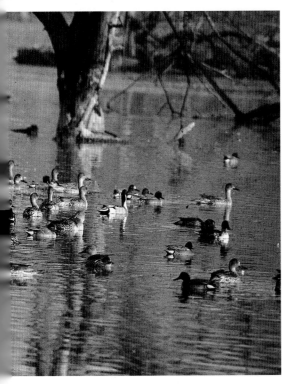

(Bottom) A frock of ducks in the open water

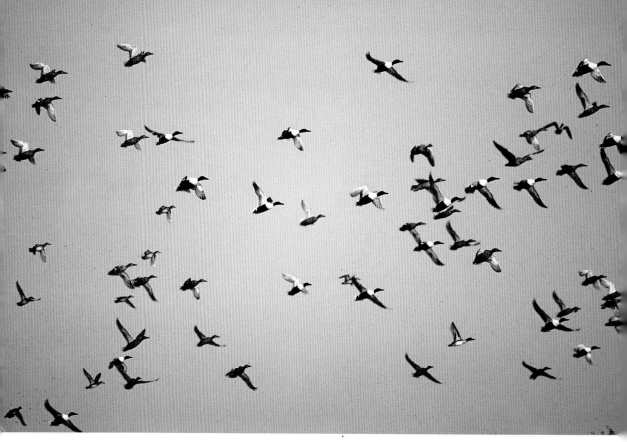

The greatest number visit the Park during February-March.

The Common Teal *(Anas crecca)* is the smallest waterfowl to visit the Park and may be distinguished from other species on that basis alone. The male has bright chestnut head with a broad green eye stripe that is distinctive but the female is very drab and looks much like a small Garganey. It can be sighted feeding in small ponds and ditches or in shallow waters, foraging, dabbling or swimming with head and neck immersed, busily filtering small food particles through the tiny lamellae along the side of the bill, eating seeds and spores. The Common Teal regularly goes out of the Park to visit the Ajan Dam and nearby fields.

The Mallard *(Anas platyrhynchos)* though wide-spread and commonly found throughout the world, visits Keoladeo in small numbers. This European Duck restricts itself to the northwestern part of the subcontinent. The male's head is green with a white neck ring and the chest is purplish brown. The female has a dull orange head, marked with a variable amount of black. As soon as it arrives in Keoladeo, the male begins to show breeding plumage and a hectic pairing begins. There is considerable competition for females and the so-called 'three bird flight' is frequently observed with two drakes pursuing a flying duck.

A vare winter visitor, the Marbled Teal *(Marmaronetta angastirostris)* is of particular scientific interest as it is thought to be a link between dabbling and diving ducks — it feeds both by dabbling or upending in

shallow water and diving like true diving — ducks. Males and females are both light brown in colour with a curious dappled appearance.

Apart from these, all the others are diving ducks. Seen in relatively deeper, open areas of the lake and considered to be evolutionarily the most advanced of wild fowl, these ducks are adapted to an almost wholly aquatic existence. They have large feet and short legs that are set well back on the body to give maximum propulsion under water. While diving, they leap from the water and enter headfirst with wings closed, making barely a ripple on the water. For this, their body is shorter and rounded. Because of the position of their feet, on land they have to walk in an upright posture so as to keep the centre of gravity above the legs — an awkward position.

The Red-crested Pochard (*Rhodonessa rufina*) is a diving duck with the behaviour of the surface feeders. The male has bright orange red-crested head, which is a peculiar feature and shines from distance. Not so vocal, this shy duck prefers to sit in the quiet of open water. It is usually seen in the middle of Mansarover Lake. It is a naturally accomplished diver and remains submerged for about 25 seconds, reaching the depth of seven to eight feet to feed on aquatic plants. It also feeds upended and occasionally dabbles on the surface or in mud.

The Common Pochard (*Aythya ferina*), another diving duck, has a chestnut head, black chest and wings and gray body. Its eyes are red like those of the Red-crested Pochard. A broad black bill is its specific identification. The female is dark brown above and lighter beneath with a dark eye.

The Common Pochard is more frequently seen feeding mainly on aquatic plants in water less than six feet deep.

The Tufted Duck (*Aythya filigula*) is the most familiar inland diving duck. Its most conspicuous features are brilliant white flanks and long drooping chest. The bill is blue, and the eyes, bright yellow. In flight, the white wing bar and pale belly is distinctive. The duck feeds almost entirely at depths of 8 to 16 feet with an average diving time of 15 to 25 seconds. It eats mainly fresh water mollusk, the larvae of invertebrates and plant seeds.

The Bar-headed Geese is so called beacuse two black bars on it's head.

(Facing page) A flight of Shoveller Ducks, these ducks winter at Keoladeo in large number.

Lords Of The Sky

A raptor surveys the marsh as what seems to be a cloud of ducks race to roost before the sun sets.

Bharatpur is also well known for the many kinds of birds of prey that frequent its hunting grounds. The term 'birds of prey' is used to describe birds that kill specially the higher form of vertebrates. Nocturnal birds of prey such as the owl hunt under cover of darkness. Other birds of prey, the eagles, hawks and falcons, are active during the day.

The most prominent among the eagles of Keoladeo is Pallas's Fish Eagle *(Haliaeetus leucoryphus)*, a brown bird distinguished by its pale brown head and neck, which flies in from the Himalaya to breed here in the winter. It is an expert hunter of fish and uses its sharp talons to snatch prey from the water and carry it up to its perch. A large bird,

Keoladeo are the Greater Spotted Eagle *(Aquila clanga)*, and Lesser Spotted Eagle *(Aquila pomarina)*, the latter being a residential bird. The sub-adults of both these eagles have white spots on their wings; hence the name Spotted Eagle. It is very difficult to distinguish between the two since both are dark eagles with white rumps. In flight, however, it can be seen that the wings of the Greater Spotted Eagle have seven 'fingers' while those of the Lesser Spotted have only six. Besides, the Lesser Spotted prefers forest tracts while the Greater Spotted dwells near marshlands. This difference in preferred habitat makes their identification when sitting on trees a little easier. Breeding of both, the Lesser Spotted Eagle and Greater Spotted Eagle was

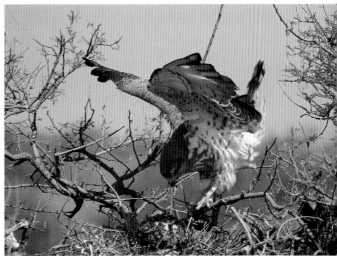

the Fish Eagle requires approximately one to 12 sq km of territory depending on the productivity of the range. The birds fight over possession of territories. Once the territory has been established, no intruder dare enter it. Two pairs of the Fishing Eagle bred regularly in the Park till 1992 but since then not a single bird has been seen here.

The other eagles that can be seen in recorded for the first time in the Park during 1989 - 90.

Short-toed Snake Eagles *(Crcactus gallicus)*, easily identified by their large head and white under feathers that contrast strongly with the dark upper ones, also breed successfully in the woodlands of Keoladeo. With the exception of the breeding season this eagle is a solitary bird, Breeding activ-

The Short-toed Snake Eagle breeds at Keoladeo. The bird is a common predator of semi-desert, cultivated land and shrub jungle.

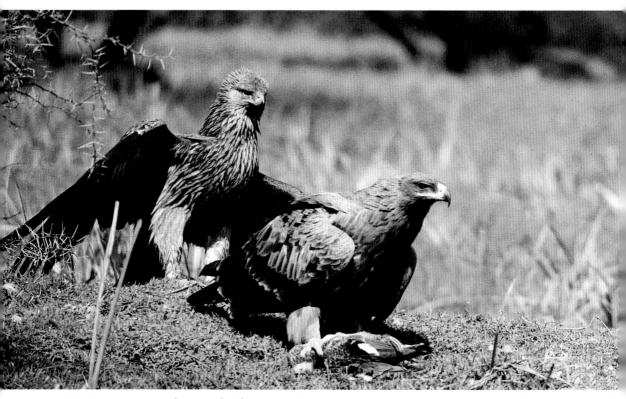

(Above) Steppe Eagles fighting over prey.

(Right) Peregrine Falcon

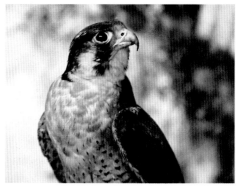

ity starts in the month of January. One or two pairs breed every year in the Koladahar area of the Park. Observation reveals that the bird usually lays only one egg. Both sexes share the incubation and the eaglet is tenderly fed by both the parents. The most preferred prey are snakes, specially the rat snake, which is why it is also called the Serpent Eagle. It also preys on garden lizards and rodents. Sometimes, it may catch venomous snakes like the cobra.

The expert snake hunter, however is the Crested Serpent Eagle *(Spilornis cheela)*. This is a dark brown bird with its under parts oscillated in white, light spots on the wings and a light brown or pale white band across the tail. It has a black and white crest on its head which, when raised in excitement and alarm, becomes very prominent. It can perch motionless for hours on a tall tree waiting for its prey.

Bonelli's Eagle, *(Hieraetus faciatus)*, a brown bird with pale markings on the nape and a long tail can be seen around Kadam Kunj area. Another resident bird of prey - the Tawny Eagle *(Aquila rapax)*, is also very active in the Park, especially during the summer when other migratory eagles return to their breeding grounds. The Tawny Eagle prefers grassy plains though

in winter it is mainly spotted around the marshlands. It generally hunts small rodents such as gerbil and weak or injured birds, and also keeps an eye out for carcasses. It will also try to snatch the kill of a Marsh Harrier and other lesser birds of prey. The Tawny and Greater Spotted eagles often fight for kill that they snatch from one another.

In winter, the migratory Steppe Eagle joins the Tawny Eagle. Ornithologists earlier classified the Tawny and the Steppe eagle *(Aquila nipalensis),* as two distinct species but now consider them as sub species, the slight differences having evolved as a result of geographically separation. In the field sometimes it is difficult to distinguish one from the other.

One or two Imperial Eagles *(Aquila heliaca),* also visit the park during the win-

ter. This is a big eagle, only slightly smaller than the Golden Eagle *(Aquila chrysaetos)* and can be recognised by its black-brown plumage with white feathers on the back.

Smaller than the eagles, but foremost amongst the birds of prey is the Marsh Harrier *(Circus aeruginosus).* The male is a

(Above)
A portrait of the Marsh Harrier, one of the most efficient birds of prey.

(Left)
The Laggar Falcon is a master hunter of grasslands. Kola Dahar is a favourite hunting ground

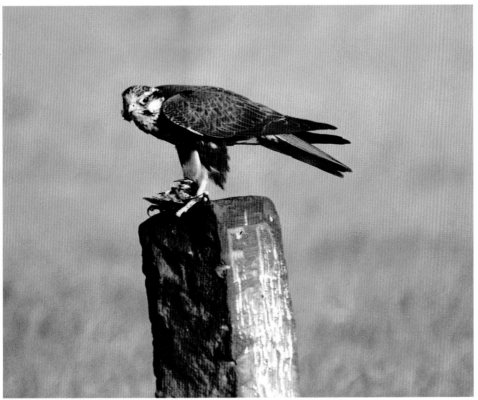

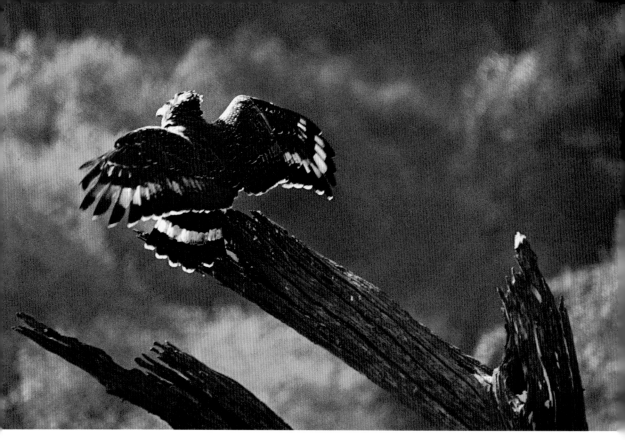

(Above) The Crested-Serpent Eagle, identifiable by its peculiar crest and oscillated underparts, can usually be seen perched on a tree.

brown bird with silvery gray wings and tail. The female can be identified even from a distance by the white buff markings on the head and leading edge of the wings. It is the most active bird of prey in the Park, with a low gliding flight that creates panic amongst the water birds. Sudden activity of birds in the marshes is usually indicative of a Marsh Harrier on the hunt. It marks its prey from the flock of birds during its low flight and catches a with its characteristic sudden mid-flight turn and dive. These birds roost in the grasslands. I have seen more than 50 Marsh Harriers roosting in the Koladhar area during their migration.

The most common buzzard found in the Park is the Honey Buzzard *(Pernis Ptilorhynchus)* This grayish brown bird feeds on mainly honey and the larvae of bees. It breeds in the Koladahar area during summer. Male and female both share incubation and feeding duties. The other is the Long-legged Buzzard *(Buteo rufinus)* which is very active during the winter. It is usually seen soaring and gliding over long distances, hovering now and then to look for prey, usually a gerbil or a lizard. The sluggish look, the moth-like wings with black crescent-like patches on the underside and a rufous white tail help in its identification. The Common Buzzard *(Buteo Buteo)*, which is common in the western part of Rajasthan also visits the Park. This is a smaller buzzard than the Long-legged, and is seen around the Koladhar area, diving for its prey, usually small rodents, from a high tree branch. Both these buzzards can be seen soaring high in the air in the afternoon.

The Shikra *(Accipiter badius)* is a small but bold and beautiful bird that breeds in the National Park. The Indian Shikra is ash gray in colour with a white breast and rusty

brown bars. The female, which has yellow irises, is larger than the male whose irises are dark red. During the breeding season, the pair indulges in a fascinating aerial courtship display. An untidy nest is made high on a leafy tree in which the female lays three to four eggs. Both the male and female take part in incubation (personal observation). The young hatch in 18-21 days and are white in colour. Initially, when the male brings in food, usually a sparrow or a lizard, he gives it to the female who feeds it to the chicks. After eight to ten days, the male starts feeding the young directly and simultaneously, the female starts leaving the nest to hunt.

The Osprey *(Pandion haliaetus)* is a magnificent bird, dark brown on top and white below with a dark band across the breast. A winter visitor to the Park, it can be seen perched on a tree near the open water which it surveys in a low flight for fish. When it sights one, it pauses in the air and dives, catching the fish with its claws. It stays in the Park for three to four months before returning to its breeding grounds in the month of March.

Vultures are nature's scavengers, different from eagles in that they are not adapted to killing and eating live prey. Their toes are shorter and claws blunter. They perform a very important function in disposing off carcasses, both in the wilderness and around human habitation. Of the vultures found in the Park, the Indian White-rumped Vulture *(Gyps bengalensis)*, Long-billed Vulture *(Gyps indicus)*, Redheaded Vulture *(Sarcogyps calvus)*, and Egyptian Vulture *(Neophron percnopterus)*, breed here. I have also seen a single Griffon Vulture *(Gyps Fulvus)*, with

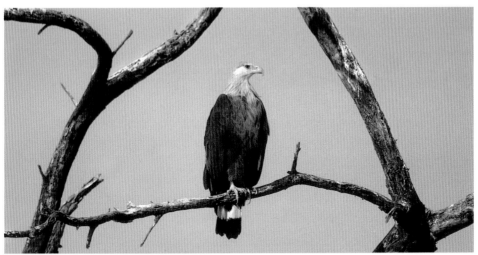

Ring-tailed Fishing Eagle.

(Below Left)
Long-billed Vulture

(Below right)
Egyptian Vulture

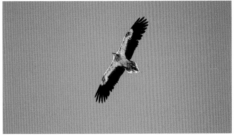

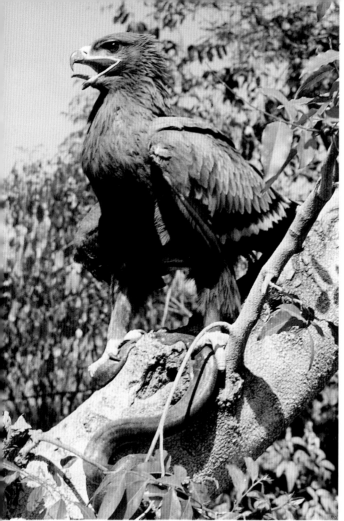

(Above) Steppe Eagle

(Bottom) Shikra feeding its young one. This bird breeds in the park making its nest high on the trees

some Long-billed Vultures in the Park.

True to its name, the Redheaded Vulture is the most beautiful of these and easily recognised among a common group by its bold, deep scarlet head, neck and legs. It builds its nest on a big tree like the Kadam or Peepal, away from other vultures in February-March. Three or four pairs breed in the Park. Despite its impressive name, it is a timid bird, sneaking in now and again to get a bite and then hurriedly withdrawing from the carcass. The number of this species in the Park is dwindling. One of the reasons for this may be the paucity of large trees for nesting.

The adult White-rumped Vulture has a white back. The juvenile is a brown-black bird. This bird used to live in colonies near villages and also bred there. It was also the most common vulture in the Park but now it is becoming rarer day by day, both here and near villages.

The Long-billed Vulture is dark brown

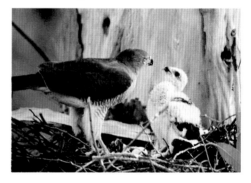

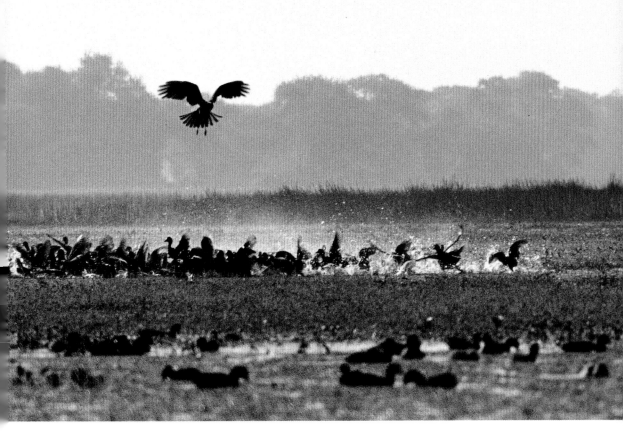

(Above) A Marsh Harrier hovers over sitting ducks.

bird with a patchy neck and head covered with brown hair. These birds can be seen in large numbers near animal carcasses. Breeding activities begin in November. Generally, these birds make their nest on a cliff.

The Egyptian Vulture differs from other vulture in shape and size. It is a white bird, smaller in size, the face, beak and throat are yellow. The beak is long but not robust as in other vultures. The feathers on the nape form a thick crest. While in flight, it can be recognised by long, pointed wings and a wedge-shaped tail. These birds breed in the Koladhar area from February to May, nesting on a high tree.

As a nocturnal bird the owl is considered to be a bad omen in India, a belief that makes its survival near villages and human habitation hazardous. However, it has a significant place among the birds of prey at Keoladeo, though studying its habits is difficult. Undoubtedly, there is certain mysteriousness about the owl that is attractive to the inquiring mind. How do they lead their daily lives and use their specially evolved eyesight and hearing? Answers to questions such as these have kept ornithologist busy for years.

The wings of owls are much less variable in shape than those of the other birds of prey. No owl searches for prey from great

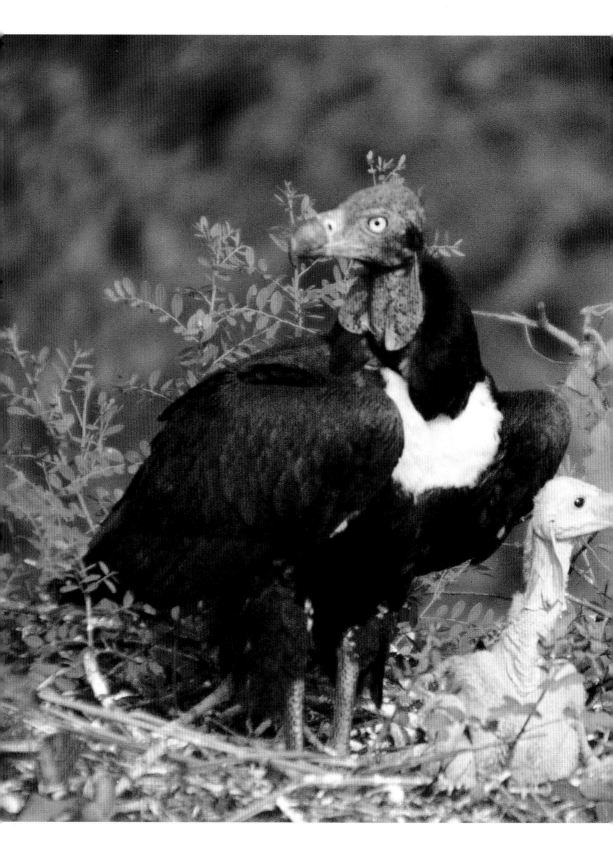

heights because this is impractical in the dark, so none has very long and broad wings. But this is no disadvantage. Their plumage, including the flight feathers, is soft and pliable. Soft feathers drawn quickly through the air produce little sound and their silent flight is an important adaptation for night hunting

The most common owl found in the Park is the Spotted Owlet *(Athene brama)*. This quaint little bird, brown in colour and dotted in white, can be identified by its relatively large head and bright yellow eyes. From close quarters, its head can be seen

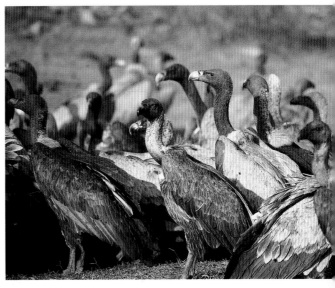

bobbing up and down as it surveys its surroundings from its perch, possibly to obtain a good perspective. It is an appealing peculiarity of this bird, as is its rather comical habit of chattering and squealing as it emerges from its hole before dusk.

Besides, the Spotted Owlet, another beautiful owl, the Collared Scops Owl *(Otus bakkamoena)*, is also usually seen near Keoladeo Temple. At times, a pair breeds in the hollow of a Babul tree near the temple. This is another delightful little brown owl

A group of Long-billed and Whiterumped Vultures. The vulture are becoming rerer day by day.

(facing page) King Vulture with young one.

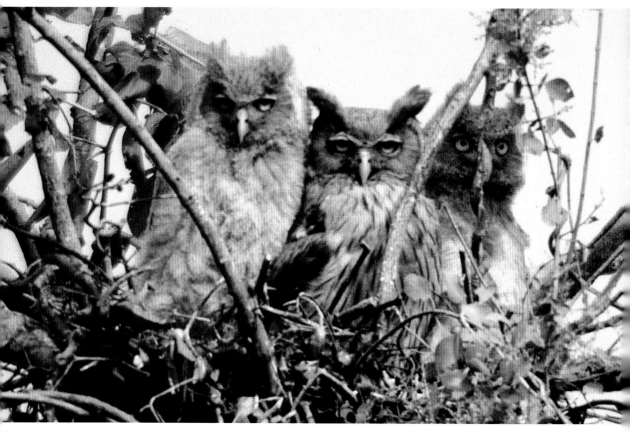

(Above) Dusky Horned Owl with young ones

(Below) Collared Scops Owl feeding its young.

(Facing page above) Barn owl

(Facing page below) A family of Spotted Owlet, perched near their nesting hole.

that has conspicuous little horns or ear-tuffs. Its name derives from the markedly pale collar around the back of its neck. Unless disturbed, it does not leave its perch during the day. At night, it reveals its presence with soft *'wheet-wheet'* sound.

The dense growth of trees in Kadam Kunj is another ideal place for sighting owls, as it is in the interior of the Park, where there are comparatively fewer disturbances. That is, probably, the main reason why the owls prefer to dwell here. Every year, two to three pairs of Dusky Horned Owls *(Bubo coromandus)* nest here. This is a large, greyish-brown horned owl with dark shaft stripes to the feathers. When nesting it usually occupies the abandoned nest of a vulture.

The Barn Owl *(Tuso Alba)*, a white owl with pale buff brown and gray upperparts with light flecks and bars, is also a resident of the Park. It usually roosts in old buildings, cliffs or big tree holes and avoids the thick forest. Barn owls mainly feed on mice, birds, insects and sometime small mammals. During breeding time, the male bird occupies a safe, large cavity. He then approaches the female and offers her food

— a mouse or a frog. By accepting the offering, she indicates her acceptance of the nest hole and moves in. The breeding commences thereafter. The female lays three to six white eggs. Both the birds share the responsibility of bringing up the owlets.

The Mottled Wood Owl *(Strix ocellata)*, found only in the Indian subcontinent, is a beautiful bird. The absence of ear tufts is more than compensated for by its grayish to light brown colour marked by a soft white fluffy half-collar below its neck. The white markings on brown serve as a good camouflage in dense foliage. Its breeding season extends from March to June and it usually nests in old tree holes.

At about 22 inches, the Eagle Owl *(Bubo bubo)* is the biggest among the owls in the Park, easily identifiable even from a distance by its large pink eyes and prominent brown horns or tufts. Both male and female look alike. In the dark of night its presence is marked by its shrill *to-whoot - to-whoot* call.

The Brown Fish Owl *(Kutupa zeylonensis)*, like the Eagle Owl, can be seen perching on strong, low branches of trees by the waterside, where it waits for its prey. At dusk, the large white patch on its neck and large bright golden eyes give away its presence. The absence of feathers on the tarsus, convenient in a bird that fishes, is another identification mark. The deep *boom-boom-boom* of its call is quite peculiar. It flies up and down in its quest for prey, at times almost skimming the water. Fish are scooped up from near the surface. Apart from aquatic animals like crabs, fishes and frogs, the bird also feeds upon reptiles, birds and rodents.

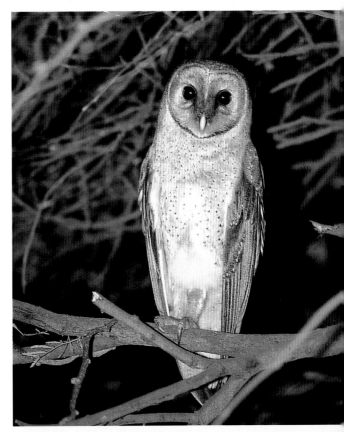

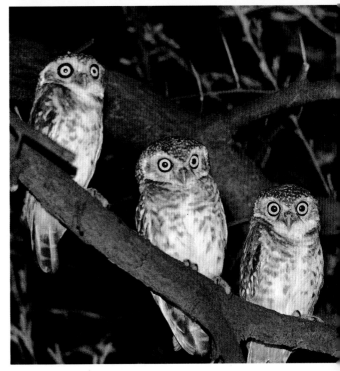

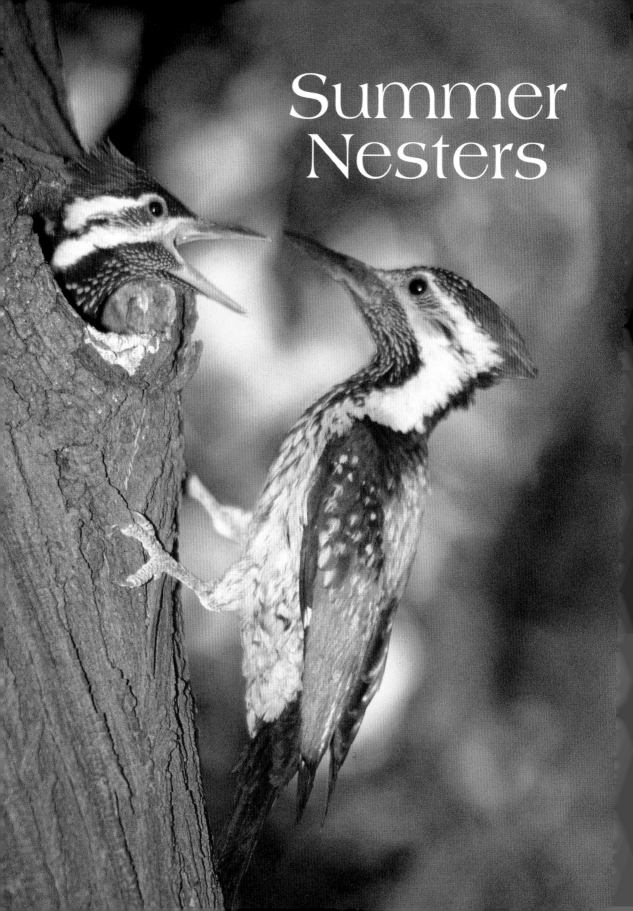

Summer Nesters

By the end of March most of the migratory birds begin to leave. Only resident birds such as the bulbul, warbler, lark, doves, etc. remain in the dry wooland. There is plenty food for them to ensure survival and regeneration. It is an unique experience to watch breeding activities of these birds during the summer. Many species lay their eggs on the ground, a few in dense grass and thick shrubs, others in the open, some in the branches of a tree or cavities in trunk of a tree. The Red-wattled Lapwing *(Vanellus indicus)* and yellow-wattled Lapwing *(Vanellus malarbaricus)*, Stone Curlew *(Burhimus oedicnemus)*, Grey Francolin *(Francolinus Pondicerlanus)*, Black Francolin *(Francolinus francolinus)*, Jungle-bush Quail *(Perdiculs asiatica)*, Rock-bush Quail *(Perdiculs Malarbaricus)*, etc, usually lay their eggs on the ground, in a natural depression or in dense grass. These nesting places are lined with small pieces of grass, pebbles and twigs.

The story of ground nesters will be incomplete without the peacock *(Pavo Cristatus)* being mentioned. A spectacular courtship, during which the male displays the full glory of his famous feathers in a beautiful dance, is followed by breeding. The female then lays her eggs in a shallow pit under dense scrub and incubates them.

Some birds like woodpecker, roller, hornbill, hoopoe, parakeet, mynah and barbet, etc. lay and incubate their eggs in the hollow of a tree trunk. During these days they can be spotted in search of cavities in trees or hollow tree trunks where they can make their nests.

The Black-rumped Flame-backed Woodpecker *(Dinopium benghalense)* is the most colourful bird in the Park. Its golden back, that shimmers brightly in sunlight during flight, and the red crest attracts not

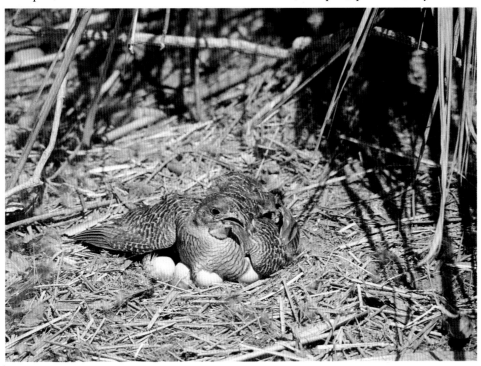

(Left)
A female Grey francolin incubating its eggs

(Facing page)
Black-rumped Flameback feeding the young. These birds mainly feed on ants and insects.

only bird lovers, but also even the average visitors to the Park. The bird has a powerful beak and neck and can bore holes several inches deep while chipping out larvae or insects from tree bark with its beak and tongue. They feed their young by regurgitating saliva or a paste of insects as food. The Yellow-crowned Woodpecker *(Dendrocopos mahrattensis)* is another common woodpecker. It is smaller than the Golden-backed, it is actually less then six inches in length. However, the *click, click* sound it makes as it flies from one tree to another can be tracked and the bird can be seen high on the branches.

The Blue Jay *(Coracias benghalensis)* is another bird common to the park. The blue-coloured bird has a rufous brown breast and a reddish-brown neck. The formation of pairs starts immediately after winter. Its nest is not really a cavity like that of other cavity nesters but is located in a big hollow of a tree. Both male and female share the responsibility of bringing up the young ones. The European Roller *(Coracias garrulus)*, a migrant, also visits the park during winter.

The Magpie Robin *(Copsychus saularis)* is a black and white bird with a long tail. It is a melodious bird that also imitates other species. It becomes very active during the breeding season when can be seen sitting on a perch singing with bill pointed skyward. The female takes the responsibility of hatching the eggs while male guards the nest. Indian Robin *(Saxicoloides fulicata)* lays its two to three eggs in holes in walls, trees or earth. As soon as chicks hatch, both parents are kept busy feeding the hungry mouths.

The Common Myna *(Acridotheres tristis)* and Bank Myna *(Acridotheres ginginianus)* are also summer breeders that lay their eggs in

(Right) Spotted Creeper feeding its young. The bird has a preferance for well-wooded areas

(Opposite page) Grey Hornbill

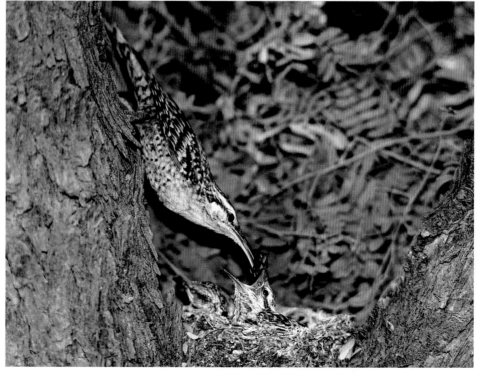

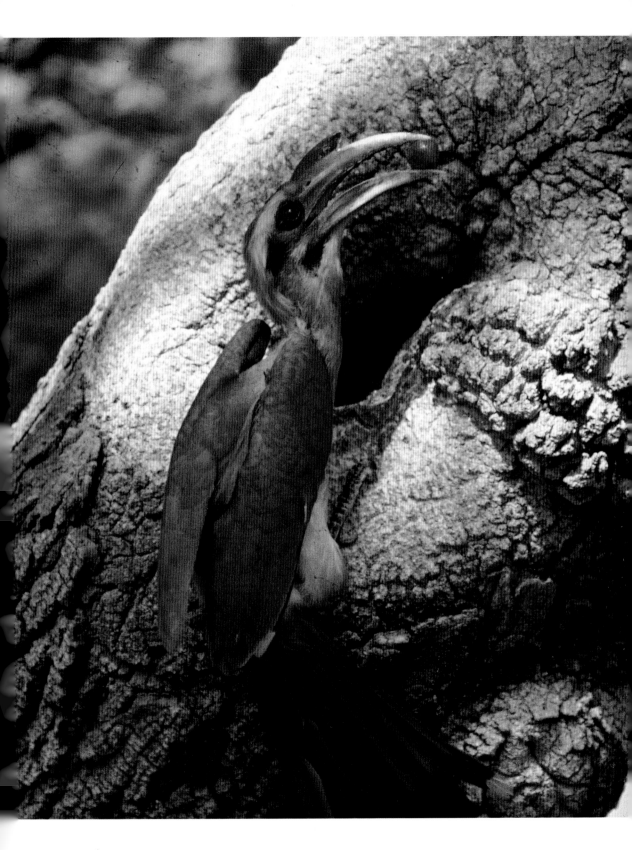

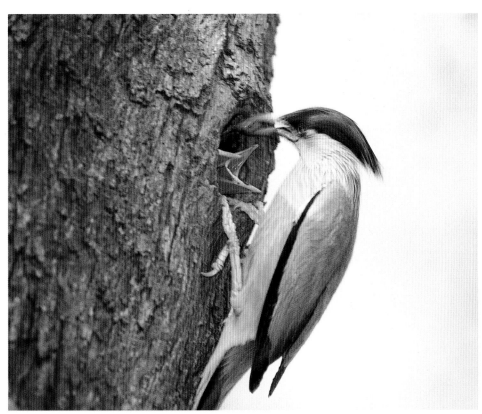

(Left)
Brahminy Starling

(Bottom)
Barbet feeding young

(Facing page)
Roller prefers fence post or earth clods in open ground for perching.

a hole. The Common Myna is dark brown in colour with bright yellow legs, bill and a patch behind the eyes. These are omnivorous birds and live in flocks. Parties of more than two hundred birds can be seen in the Park during March-April.

The Grey Hornbill *(Tockus birostris)* is the only hornbill found in the Park. This brownish-gray bird can be recognised even from a distance because of its curved, blackish bill and long tail. Its another peculiarity is a pointed casque on its black bill. During breeding it searches a cavity in the trunk of a tall tree which the female, enters to lay her eggs. The male then seals the cavity with mud, leaving only a small hole through which he feeds her. The female, whose wing quills molt during this period, stays sealed inside till the young ones are a week old. Feeding her is the responsibility of the male. When the young ones are about a week old, the female breaks the mud wall and comes out of the cavity. Thereafter, both feed the young ones.

The Hoopoe *(Upupa epops)* is a rufous orange bird with striking black and white

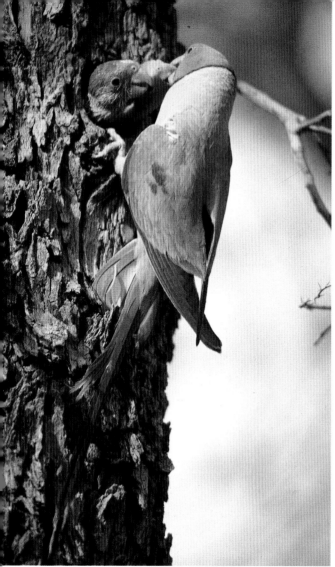

Plum-headed Parakeet feeding young. This colorful bird prefers the Kola Dahar area.

markings, like those of zebra, on its wings. It also has a crest, about one-inch long. Whether crest is compressed or fanned, it always attracts the watchers. Its name probably derives from the deep mellow *hoo-po-po* sound it makes. After laying her eggs, the female spends most of her time in the nest. During this time, the responsibility of feeding lies with the male.

Two species of parakeets are visible here. The Rose-ringed Parakeet *(Psittacula krameri)*, which is commonly found all around the Park, and the Plum headed Parakeet *(Psittacula cyanocephala)*, which can be seen away from the marshes in the dry areas of the Park like Koladhar. This is a green bird with bluish red head and a bright maroon patch on the wing shoulder. The female is a little different and has bright yellow collar around neck. These parakeets occupy the nest holes of woodpeckers and barbets. The incubation of the eggs is carried out by the female, but once the chicks hatch, both male and female share the duty of rearing the young ones.

The Brahminy Starling *(Sturnus pagodarum)* is the most vocal and daring of cavity nesters of the Park. Its impudence

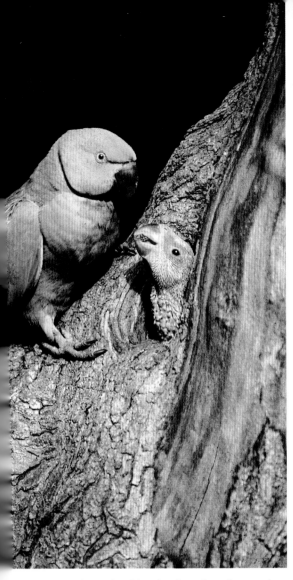
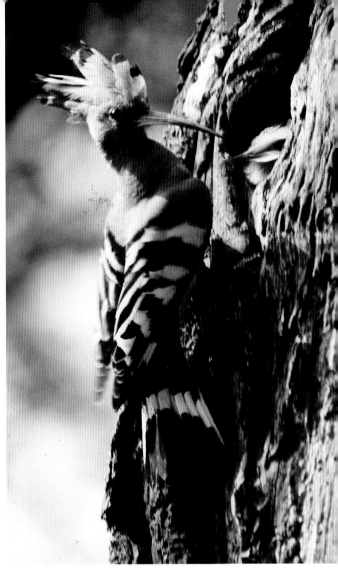

can be judged by the fact that if any other bird is already nesting in the cavity, the Brahminy Starling will try to force it out. Both male and female share breeding duties.

The Coppersmith Barbet *(Megalaima haemacephala)* is another one of the more beautiful birds of the Park. With its yellow throat and crimson breast and forehead, this green-coloured bird is certainly one of nature more spectacular creations. The distinctive *tuk-tuk-tuk* sound it makes marks its presence even from a distance, otherwise its green colour is a highly effective camouflage amidst the green foliage. In the breeding season the male offers the female figs of the Banyan and Peepal trees. Once the eggs are laid, both birds take turns in the nest. Brown-headed Barbet *(Megalaima virdis)* is a large bird as compared to the Copper smith. This green colored bird can be recognized by its monotonous *Kutroo, Kutroo, Kutroo* call.

(Above)
Hoopoe feeding to its young

(Above left)
A male Rose-ringed Parakeet on its cavity nest. Both male and female rear the chicks.

Kingfishers

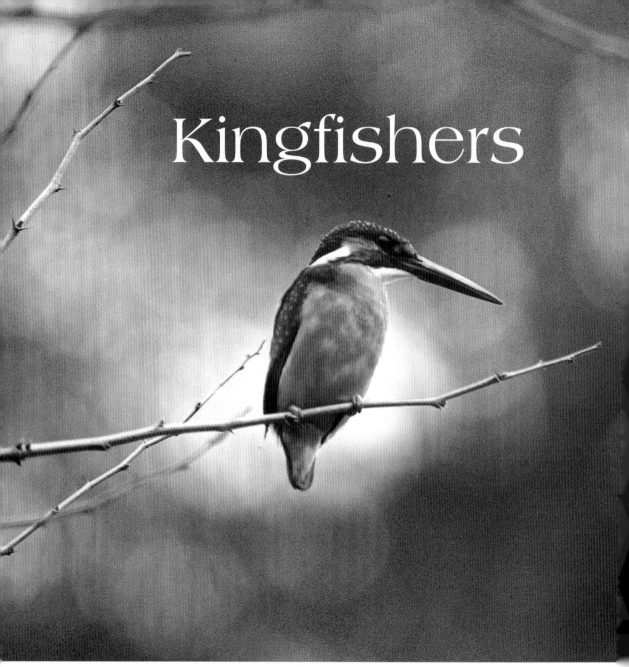

(Above)
Common Kingfisher

(Facing page)
White-throated Kingfisher

The kingfishers, also known for their brilliant plumage, also breed in the park in a cavity. These cavities are dug in sand — a horizontal tunnel in the earth bank approximately two to three feet long with an egg chamber at the end. After pairing, kingfishers choose a suitable spot for excavating and start digging with their beaks. I have seen a pair of kingfishers digging their nest near the canteen at Keoladeo Temple. They started their excavation on a slightly raised mount near a water pond. It took them nearly 10 days to complete their nest. It was really breathtaking to see them digging their nest with their beaks, leaning on their wings as they sweep out dust with their feet. Both

single chick needs a small fish every hour, which means that the parent birds have to catch six to seven fishes per hour in addition from feeding themselves. The demand for fish by the chicks is so high that the parents have no time even to clean their nest. The tunnel smells of dropping and regulated fish bones.

The Common Kingfisher is a small turquoise-blue and orange bird, usually seen near the lake as a green blue streak darting around the water. The bird can be recognized by its sharp *chi-chi* call from a distance. It breeds from April to August and both birds share the nesting activities.

The White-throated Kingfisher is also common to the Park. It has turquoise blue color with a deep brown head and neck. Its coral red bill, white throat and crest are

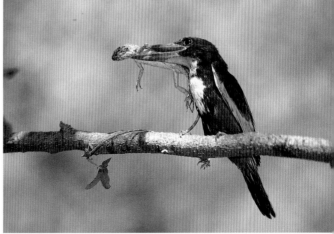

birds take part in making the nest simultaneously. Kingfishers dig an upward sloping tunnel. Even though I knew where it was, it was really difficult to locate that tunnel behind the foliage.

After laying the eggs both birds incubate the eggs for about 20 days. After the hatching, the parent birds have no time for rest. According to a study conducted, every very conspicuous. This bird is easily recognized from its musical *"kili-li-li"* calls. The White-throated Kingfisher is mainly a plain dweller and can be seen in every part of the Park. It is not essentially a fish eater but can also feed on insects, small reptiles, chicks of birds, rodents, frogs, etc. The bird normally lays five to seven eggs in a tunnel chamber and both birds share the parental

(Next page)
Black-capped Kingfisher

(Page-99 above)
A rare albino Kinghfisher and (below) Pied Kingfisher

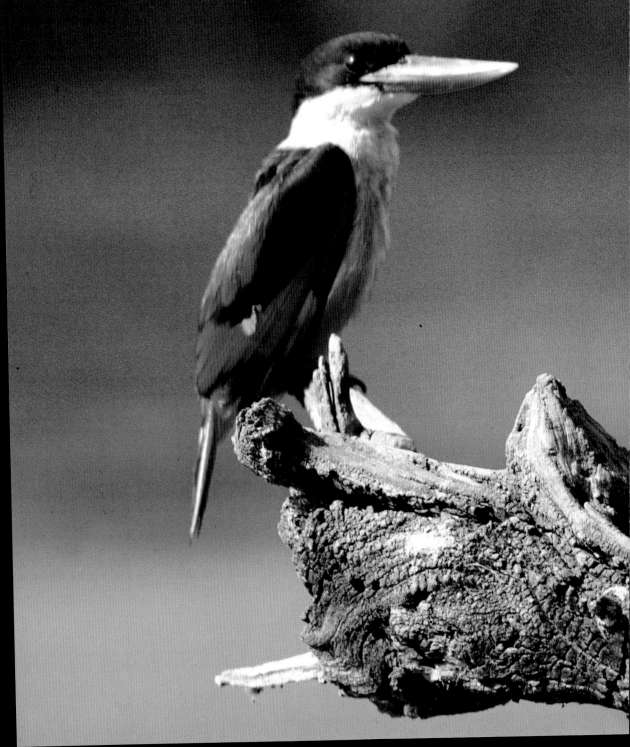

duties. These birds also do not clean their nest and remains of the feed and droppins cast a foul smell.

The Lesser-Pied Kingfisher is also a resident of the Park. Similar in size to the White-throated, it can often be seen hovering over ponds, lakes, etc. The male and female of these black and white birds look alike except for the two black stripes on the chest of male – the female has only one. The fishing technique of the Pied Kingfisher is very peculiar. The bird hovers at one point and remains stationary for quite some time. When it a fish on the surface of water, it dives down into the water. The number of these birds increases during the winter. When the bird is on wings its attractive calls *chirruk-chirruk* are heard.

The Stork-billed Kingfisher and Black-capped Kingfisher are shy birds that are local migrants and visit the Park during winter. The Black-capped Kingfisher is a deep blue and pale rust coloured bird with a black crown and a white ring on the back of the neck. It is easy to locate this bird once you know its perch because it regularly occupies the same hunting post.

The Stork-billed Kingfisher is a large bird as compared to other kingfishers. The upper parts of this bird are greenish-blue while the lower parts are brownish-yellow with dark brown head, but the bird is identified by its enormous red bill. This kingfisher is a noisy bird and its shrieking *ki-ki-ki-ki* calls can be heard from a distance. It likes thick leafy foliage overhanging water in which it sits motionless on the lookout for fish.

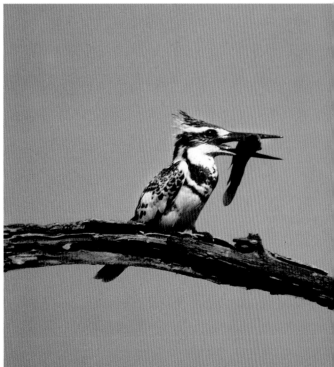

Mammals and Reptiles

Black Buck prefer the grassland area of Kola Dahar.

(Bottom) A male Sambar deer

(Previous page) A herd of Chital. The spotted deer is ususally seen in herds.

Apart from birds the National Park is also known for large mammals. Spotted deer or Chital are a common sight though they do not like to enter the water and can be seen around the lakes and the woods. Today, the population of Chital *(Axis axis)*, has crossed the 500 mark. Blue Bull or Nilgai *(Boselaphus tragocamelus)*, the country's largest antelope, is also common here. The Blue Bull is a land animal and generally does not enter the water, but here it can often be seen here grazing in water. The bulls gather together for most of the time except from November to January, which is the breeding period herds over fifty-sixty Nilgai are commonly seen in the summer.

Sambar *(Carvus unicolor)*, the largest Indian deer, is dwindling in number and becoming rarer day by day. If you are lucky, you can spot a Sambar in the water or on a raised mound. The population of Sambar in the Park today stands at approximately 20 animals, about the same as it was 35 years ago. Schaller: a scientist who has worked in the park in 1965-66.

Another beautiful Indian antelope, the Black Buck *(Antelope carvicapra)*, is a prized resident of this Park. Schaller had estimated 70 black bucks in 1966.

According to VS Saxena, in 1973, 19 Black Buck, 310 Spotted Deer, 28 Sambar, 251 Blue Bull, 191 Wild Boar and 2 Hyena were counted. Three Hog Deer *(Axis porcinus)* were also part of the Sanctuary, but the floods of 1972 flushed them out. Today, there are about 20 Black Buck confined to the dry lands. Black Buck were also flushed out by the flood. They were reintroduced from the Talchhapar Sanctuary in Churu District. The population of Sambar has not increased either, so much that they may have a problem with inbreeding, though few Sambar were brought in from the Jaipur zoo in 1998-99. Wild boar can be seen all over the Park.

Feral cows (domestic cattle that have become wild) are becoming problem for the Park. There were 450 feral cows in

The Blue Bulls are the biggest antelope of the Indian sub-continent.

(Below left) A heed of female Blue Bull

Among the mamels to be seen in the Park are the hyaena (left), the wild bear(below right) and the Jungle Cat (below left)

(Facing page) The shy jackal (above) and the rare Fishig Cat (below) may also be spotted by the lucky visitor.

1985. During 1991-92 the number of these cows crossed 1000. A drive to capture and release them outside the Park was initiated by Dy Chief Wildlife Warden Mr AS Brar and Range Officer Mr Daulat Singh Shaktawat in 1992-93. More than 300 feral cows were captured and released in the ravines of Chambal but they remain a problem particularly as their number is increasing at a rapid rate.

The herbivours have no natural predator in the Park. There were leopards in this area during sixties – the last leopard was shot in 1965. A lone Leopard was spotted here from September 1987 to May 1988 but not after. Now, hyenas and jackals, the main predators of the Park, are a hardly any threat to these big animals.

There are also a few other mammals such as the Jungle Cat *(Felis chaus)*, Porcupine *(Hystrix indica)*, Palm Civet, *(Paradoxurus hermaphroditus)*, otters *(Lutra perspicillata)*, and Fishing Cat *(Felis viverra)*. Otters and the Fishing Cat are efficient fish predators. Both these species are becoming rare in this part of the country as well as in the Park. The Leopard Cat *(Felis bengalensis)*, and the Pangolin *(Manis crassicandata)*, which

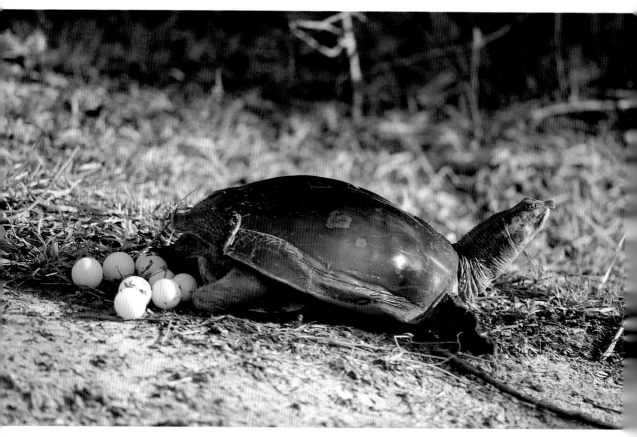

(Above) Turtle laying her eggs. The Park has seven species of turtle.

(Right) The deadly Cobra

used to be found in the Park (Saxena 1975), are not seen today.

Keoladeo National Park is also known for reptiles. Many types of snakes are found here – Cobra *(Naga naga)*, Krait *(Bungarus caerulus)*, Russel's, Viper *(Vipera russelli)*, Dhaman *(Ptyas mucosus)*, Sand Boa *(Eryx johii)*, Copper-head *(Elaphe radiata)*, Common Wolf Snake *(Lycodon aulicu)*, and Checkered Keelback *(Xenochrophis piscatop)* to name a few. The most often seen, of course, is the Indian Python *(Python molurus)*, the biggest snake in the country, which attains maximum length of up to 20 feet. Though it is a large and bulky reptile, it is difficult to spot because of its yellowish-white colour, which camouflages it beautifully. The whole body has a series of large, roughly quadrate patches from neck

to tail. The patches are generally of the same colour as the body and are broadly outlined with black or dark gray.

Pythons prefer the higher, drier area of the Park. They occupy the burrows of porcupines, jackals and monitor lizards. I have even seen pythons in termite mounds and tunnels made by nesting kingfishers and also in hollow tree trunks. During 1994-97, a few pythons lived in the trunk hole of a

Babul tree near the cafeteria at Keoladeo temple. Although they were of medium (four to seven feet only) they fascinated the tourists visiting cafeteria.

Burrows and places where pythons are always seen are known as python points or python holes. There are about 48 identified python points in the Park, some of them are famous for spectacular sightings. These are situated in saline patches where soil is not hard and it is easy to burrow. These burrows make cozy chambers for pythons both in winter and the summer. They are dug in such a manner that water does not enter even during the monsoon and are usually located in the dense shade of trees such as the *Salvadora persica*, *Salvadors Oleoides* and *Juliflora* which help in cooling the burrows during the hot months.

Reptiles generally hibernate during the cold season in a hole or tree trunk but surprisingly, pythons are seen more often in the Park during winter. They rest inside the burrow during the cooler nights of winter and come out to bask near the burrow during day, when they can be seen lying in sun to raise their body temperature. There are some points where pythons can be seen in clusters of six to ten. I once saw a cluster of 14 pythons lying next to each other in the bright sunlight. As the summer approaches, they do not need to bask but increasingly need to shelter in the cool moistness of the burrows during the hot day and so come out when it is cooler at night. Naturally, the numbers of sightings decrease.

Pythons can feed on anything, big or small: frogs, lizards, ducks, peafowl, hare, porcupine, jackal and Chital. In Keoladeo, they feed mostly on birds. The python has an interesting hunting technique. It moves very slowly, in a surreptitious manner, or lies motionless and waits for prey. As soon as a prey is within reach, the snake coils itself around its body, slowly tightening its grip. The python then inhales. As its lungs are situated longitudinally along the body, the prey is squeezed tightly when it does

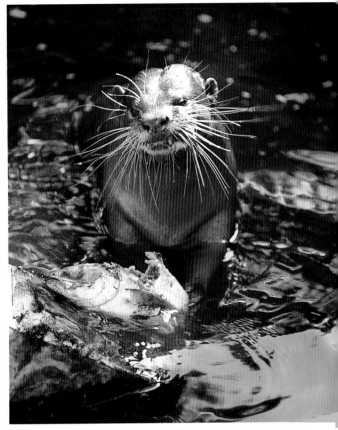

The plentiful fish in Keoladeo's lakes also support a population of otters.

(Bottom) Palm Civet.

(Above)
A colorful caterpiller

(Bottom left)
A spider

(Bottom right)
Dragon Fly mating. The Park has many species of aquatic and land insects.

(Facing page)
A python basking on a babul tree

this and, being unable to breathe, suffocates to death. The python then starts feedings, swallowing its prey whole, headfirst. Depending on the size of the prey, the python may not need to feed again for some days and lies still untill the meal is completely digested.

Pythons mate in winter. In Keoladeo, however, mating starts in the month of February and continues up to March. The temperature also helps breeding as it is springtime in the Park. During these days, much activity can be noticed as the reptiles cover long distances in search of a mate. Three to four months after mating, the female lays 20 - 60 soft white eggs, which she broods. Eggs hatch after 50 to 60 days. The hatchlings measure from 69 to 75 cm. I have seen young pythons in the month of July-August and also shells egg shells. Young pythons grew very fast and they are able to breed at the age of five years when they are about than 10 feet long. Death or mortality of pythons in the Park occurs due to trampling by ungulates and feral cows. Sometimes porcupine quills are also found on dead pythons. A trampled python being injured and incapacitated, becomes easy prey for predators like the hyena and jackal. I have seen a jackal eating a python.

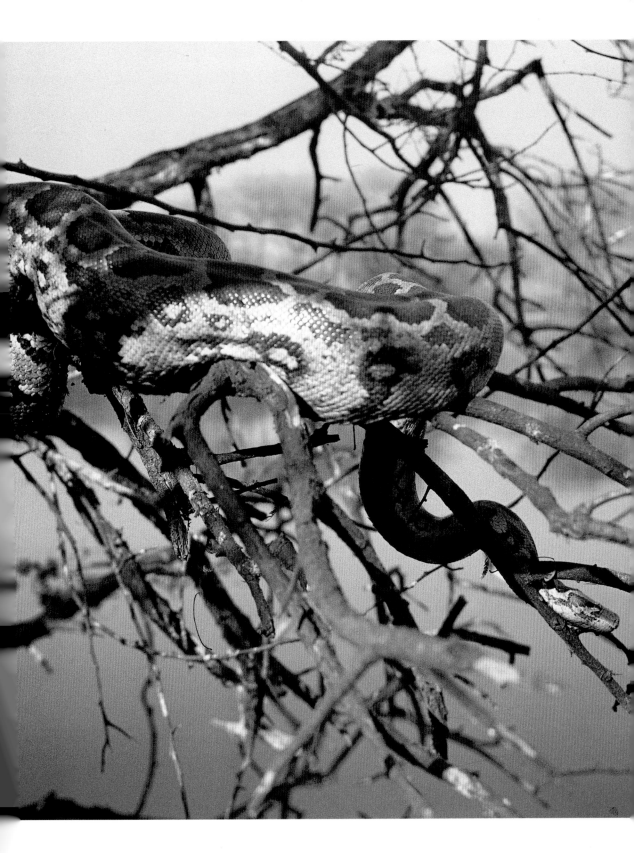

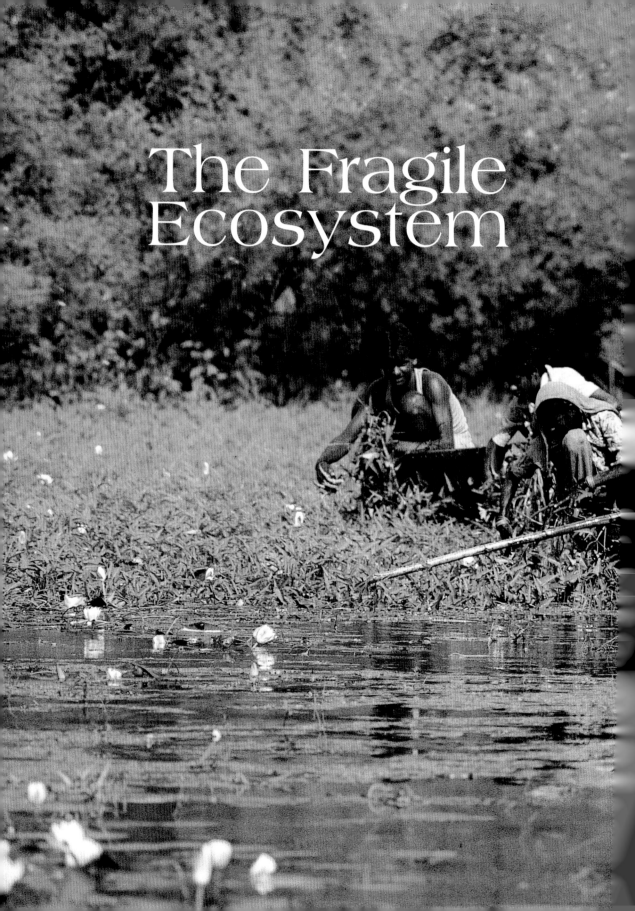
The Fragile Ecosystem

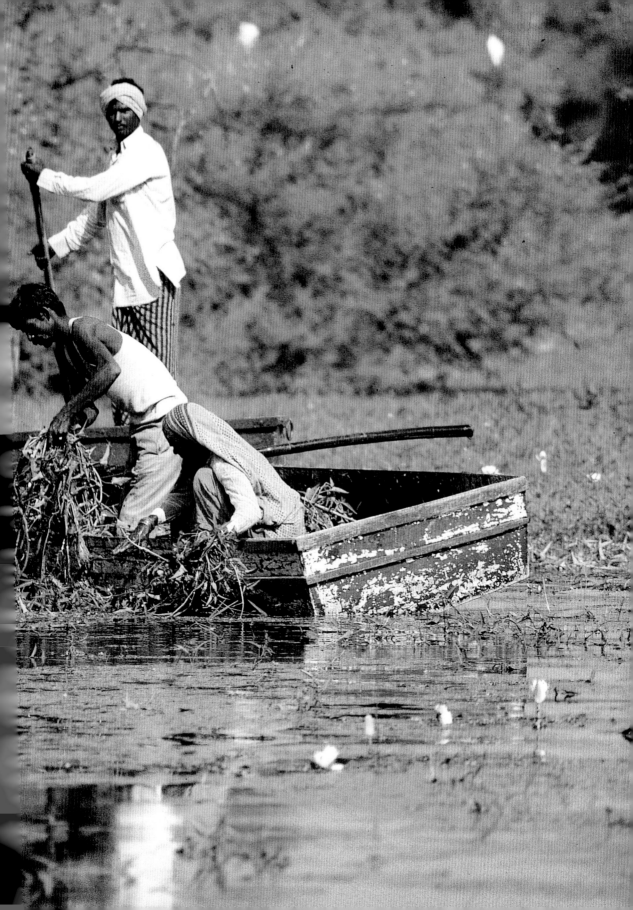

(Below) Since the unchecked spread of grasses is a problem in the Park, passes allow neighbouring villagers to cut and carry fodder from the meadows.

(Facing page) Butterflies such as the Plain Tiger (above) and the Peacock Pansi (Below) help plants propagate by taking pollen from flower to flower.

The environment of the Keoladeo National Park is peaceful and tranquil. Vegetation is also diverse as it includes woodlands, grasslands, shrubs, and wetland species. The Park is being managed with the objective of maintaining an ecological equilibrium and arresting the process of plant-succession at a stage which is ideal for bird life. In addition, the mosaic of habitat is to be maintained to cater to the needs of different species.

Thus, the park has an assured supply of water essential for survial of any wetland. Keoladeo is a shallow, saucer-like lake with dykes and sluice gates that help water spread over a large area as well as holding it for a longer period. This, combined with the silt, bright tropical sun, changing moisture conditions of soil and the drying of the lakes every year, make Keloladeo an ideal place for the development of a bio diversity of habitats ranging from swamps, shrubs, wet prairies to dry savanah. Hence, it attracts

The sanctuary is located at the north-western end of the Indian Peninsula in the great plains of the foothills. On the established fly-way of the migratory birds in the flood plains of the Gambhir and Banganga rivers, it is ideally situated for water birds. Some flood water is stored in the old flood control cum irrigation dyke known as Ajan Bund constructed by the Maharaja of Bharatpur between 1726 to 1763. When released, water from the bund fills the low lying areas of the sanctuary.

water birds, land birds and water animals. Barring a few higher areas, almost the whole of the sanctuary is covered with water during the monsoon. This water decreases within a month and then a more stable waterspread is formed over 8 sq. km. The lakes are ephemeral and retain water for a short span of time and dry up during summer. This cycle has, over a period of time, has established a unique ecosystem consisting of fresh-water swamps.

The aquatic vegetation and invertibrate

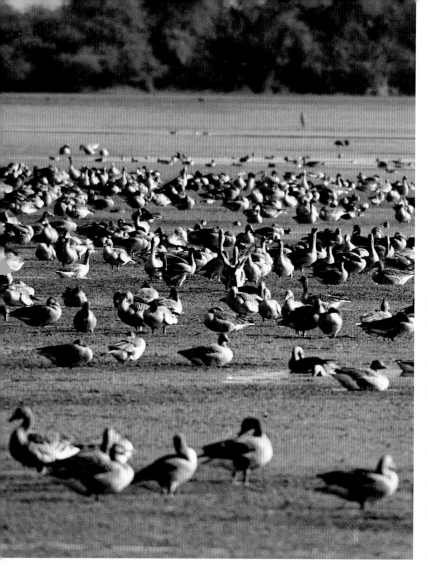

Graylag Geese

*(Right)
The lake in hte misty light of down*

fauna support fish and frogs. These in turn meet the growing demand of water birds including egres, herons, storks and darters and cormorants. The extensive wet prairie draws migratory waterfowl in their thousands. The waterfowl attract predatory birds – egales, owls and hawks – which form the apex of the biological pyramid. The bio-energy generated in plant producers flows from lower forms of animal life to higher forms till it returns to the ground through death and decay and is released as free elements by the action of fungi. These free elements are again pumped by plants for synthesis as energey. The endless process goes on in the nature's energy cycle.

Now it is established that most important aspect for Park maintenance is water management. The quantam and time of release from Ajan Bund varies according to the monsoon. The entire water management is dependent on rainfall. Water for the Sancutary should be released as soon as Ajan Bund gets the rain water. The annual requirment of the water in the Park is about 500 mcft. Nesting population and nesting success of these birds were studied by BNHS from 1980 to 1990, looking at

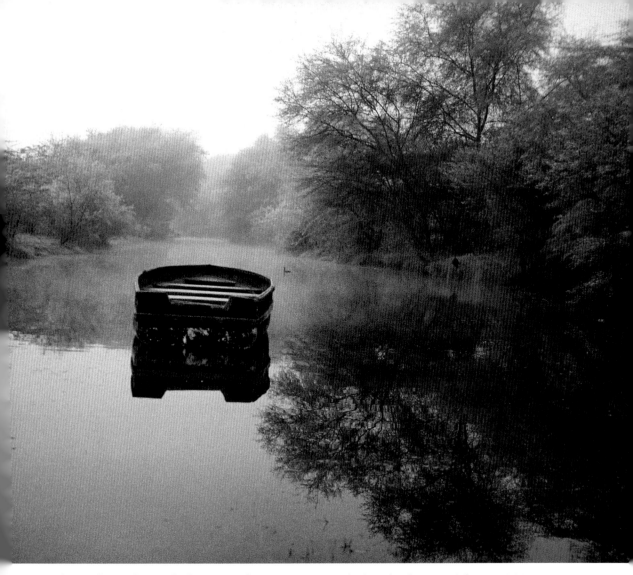

their relationship with the input of water. According to the report, the total number of nests covering all species varied from 610 (1986) to 8468 (1988) and the nesting success from 78 (1986) to 7222 (1988) during the period of study. The water intake was 0.6 mcft in 1986 and 508.5 mcft during 1988. There is a positive correlation between the quantum of water released into the Park, the nesting population and nesting success. Whenever the water level drops there is always la drop in breeding activities.

The number of waterfowl also fluctuates according to the water level in the Park. As per a study done by the BNHS during 1983 to 1989, the pattern of seasonal fluctuation in abundance of individuals and species of waterfowl was positively correlated with the water supply. The peak of 1985-86 was the maximum ($>24,000$) while that of 1986-87 was the minimum (<4000). The water supply of water to the Park was started on 18 july in 1985-86 and quantity of water was 567.4 mcft. But during 1986-87, only 0.6 mcft water was given to the Park.

The quality of water also affects the activities of birds in the Sanctuary. This has deteriorated and now contains pesticides

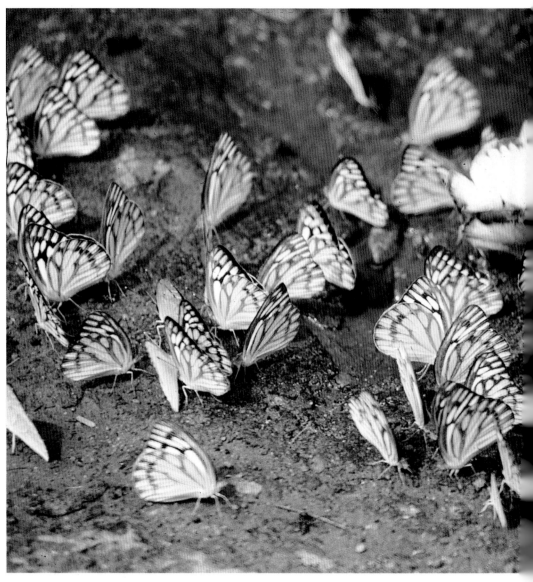

A group of butterflies

and fertilizers used by farmers and drawn through Banganga and Gambir rivers to the Ajan Bund. Moreover, once the water reaches the Sancutary, it remains stagnant there till the area dries up. According to the report the water of the Park was slightly acidic during 1982. There was a drop in oxygen levels in the first half of the 1980's with a slight increase afterwords. Decomposition of organic matter entails utilization of dissolved oxgen, the more the organic matter broken down, the more the dissolved oxygen consumed. However, the two water samples analysed at the Industrial Toxicological Research Centre, Lucknow, do not indicate an alarming situation.

Similarly, uncontrolled grass also becomes problem for Park management. Grazing of domestic cattle was allowed in the Park before 1982. After cessation of grazing, the most conspicuous changes in the habitat are caused by uninhibited

wallowing; there was increased competition between the ungulates and cattle – but known areas of waterfowl have become lifeless after the increased growth of grass. Today Bird sightings becomes difficult day by day whereas previously, these areas attracted large flocks.

According to the BNHS report, habitats with 30 - 60 cm water were utilized more for feeding. Average water depth in the feeding habitats was the lowest for the Barheaded Goose (9 cm) and highest for the Coot (58 cm). Six out of nine common species of waterfowl utilized mostly sparse grass habitat for feeding. The next favoured habitat for feeding was open water with floating vegetation. The Bar-headed Goose was a specialist which used grazing technique most of the time, while the coot and shoveller were more generalist in their feeding method. Resting habitat was different from that for feeding except for the Wigeon Greylag Goose and the Bar-headed Goose. The Bar-headed Goose had least overlap with other waterfowl species in habitat, water depth and feeding method. Shoveller had maximum overall overlap with the Garganey Teal and Common Teal in different resource axes.

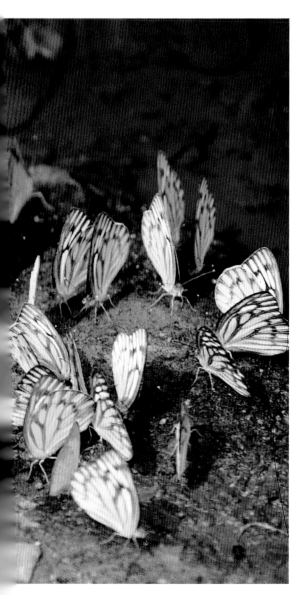

growth of certain species of plants. *Paspalum distichum* grass has become excessively dense in the aquatic area. This is an amphibious grass thought to be present in the Park earlier, though it was also but not prominent before 1982 because of overgrazing by domestic cattle. Now this grass is invading open water and affecting the waterfowl population. According to Park management, grazing did more harm than good – floating nests were destroyed by trampling and

But Park management mentioned that certain species such as Greylag Goose and Bar-headed Goose have benefited by these changes in the habital and their population has increased markedly. Secondly, four species of egrets also show a preference for these grasy patches.

To check the uncontrolled growth of *Paspalum distichum, Cyperus alopecuroides, Vetiveria zizanioides, Desmostachyh bipinnate* and other grasses, areas were bulldozed during the summer. This prooved effective

A Black Francolin. Males are often heard calling from a raised mount

for one to two years. And results obtained so far indicate that the bulldozed areas attracted more waterfowl. Controlled burning, also tried experimentally by the management, had good results as burning releases nutrients and there is improved submerged and floating vegetation. But it has adverse effect too – microorganisms are burnt and plant succession starts *ab-initio* and there may be chances of fire accidents.

Manual cutting is being followed since 1991. As the area starts drying in April, permits are issued to villagers at a nominal rate. Whatever grass dries and submerges under the surface of water, is pulled out by villagers and taken home after drying. They use it as fodder. After the water-logged areas dry, the grass is scraped from the ground. This operation is regulated and areas with thick growth are taken up first. By the time water has to be inundated the areas are completely scraped off. Nearly 4000 permits were issued for six months. Each head load weighed 30 kg net weight. As two head loads were extracted per family, nearly 43,200 tons of grass was extracted in six months.

Thick growth of *Cyperus alopercuroides* grass is bulldozed and after drying, heaped and burnt. During dry spells Khus, *Vetivera ziznoides,* grass proliferates. Manual extraction is undertaken and the slips given to the Soil Conservation Department to be used for plantation purposes. Vilayati babul, *Prosopis chilensis,* has also become nuisence in the Park and has taken over large area. This tree is considered a weed as it has no wildlife value other than shelter. However, it suppresses other vegetation. Cattle dung and dung piles of ungulates help the germination of this tree take place. This is

checked when the areas are water-logged, but in years of drought these trees come up along the banks of the water areas. Extraction of this is also manual. Water hyacinth *(Eichhornia crassipes)* also become problematic. It is a floating plant and invades the open water very fast. Removal has to be a continuous process as it progagates quickly and, since water is taken from one block to another block, it spreads very fast.

The Park management is very active in the improvement of Ghana. They start demanding water from Ajan Bund as soon as it gets water and try to keep constant water level during successive years. So as far as possible, variation in the quantum of water in Park is minimum. Initially, the water level is kept between 20 and 25 cm and after all other blocks are filled, the level

is raised to about 120 cm. This is to facilitate feeding habitat for egrets while the other blocks are being filled. When the blocks are flooded the vegetation begins to float in some areas while in others areas it begin to grow and the egrets will have no perch. Usually, during this period they go outside the Park. If Block B is provided with sufficient water, between 20 and 25 cm, these birds may remain there in hundreds.

Water level will be kept between 20 and 30 cm up to March in blocks F (Kadam Kunj area) L and portions of E and K. These are the areas where the Siberian Crane usually feeds. Early drying up of these areas will the cause the Cranes to desert the areas. Water blocks, which deteriorate owing to the high decomposition of organic matter, should be let out of Park, a week after filling.

They can be filled again later. This will reduce the impact of changes in the chemistry of the soil. Drying up of the area during summer is very essential and May, June is the ideal period. No attempt should be made to retain water even at the minimum level in the Park during this period except in pools. The Ghana canal, which brings in water from Ajan Bund, has to be desilted on a priority basis.

The Park, a bird haven since its inception in 1902, figured on the world map because of the wide diversity of its fauna and flora. Faunal diversity encompasses aquatic invertebrates and large mammals, as well as representatives of fish, reptiles and avians. Its importance has increased with nearly 374 species of avifauna and as the only winter resort for the highly endangered species – the Siberian Cranes in south east Asia. This makes Ghana unequal in the world. But as all wet lands are fragile, this sanctuary is also sensitive. The slightest negligence can lead to the loss of a 250-year long fragile system. That is why continuous monitoring is needed to study the changes in the ecosystem.

The check list records 378 species of birds as compared to 368 in 1990 by Kailash Sankhala. It shows activity of birds month by month. Dots represent presence, solid squaires stand for nesting activity.

CHECKLIST OF BIRDS OF BHARATPUR

COMMON NAME	Scientmfic Name	JAN	FEB	MAR	APR	MAY	JUN	JUL	AUG	SEP	OCT	NOV	DEC
Great Crested Grebe	**Podiceps cristatus**												
Grebes	Podicipedidae	●	●								●	●	●
Black-necked Grebe	Podiceps nigricollis	●	●								●	●	●
Little Grebe	Tachybaptus ruficollis	●	●	■	■	■	■	■	■	■	●	●	●
Pelicans	**Pelecanidae**												
Great WhitePelican	Pelecanus onocrotalus	●	●	●							●	●	●
Spot-Billed Pelican	Pelecanus philippensis	●	●	●							●	●	●
Dalmatian Pelican	Pelecanus crispus	●	●									●	●
Cormorants	**Phalacrocoracidae**												
Great Cormorant	Phalacrocorax carbo	●	●	●	●	●	●	■	■	■	■	●	●
Indian Cormorant	Phalacrocorax fuscicollis	●	●	●	●	●	●	■	■	■	■	●	●
Little Cormorant	Phalacrocorax niger	●	●	●	●	●	●	■	■	■	■	●	●
Darter	**Anhingidae**												
Oriental Darter	Anhinga melanogaster	●	●	●	●	●	●	■	■	■	■	●	●
Herons,Egrets,Bitterns	**Ardeidae**												
Grey Heron	Ardea cinerea	●	●	■	■	■	●	■	■	■	■	●	●
Purple Heron	Ardea purpurea	●	●	■	■	■	●	■	■	■	■	●	●
Indian Pond Heron	Ardeola grayii	●	●	■	■	■	■	■	■	■	■	●	●
Cattle Egret	Bubulcus ibis	●	●	■	■	■	■	■	■	■	■	●	●
Great Egret	Casmerodius albus	●	●	■	■	■	■	■	■	■	■	●	●
Intermediate Egret	Mesophoyx intermedia	●	●	■	■	■	■	■	■	■	■	●	●
Little Egret	Egretta garzetta	●	●	■	■	■	■	■	■	■	■	●	●
Black-Crowned Night Heron	Nycticorax nycticorax	●	●	■	■	■	●	■	■	■	■	●	●
Striated Heron	Butorides striatus	●	●	●				■	■	■	●	●	●
Cinnamon Bittern	Ixobrychus cinnamomeus	●	●	●	●	●	●	■	■	■	●	●	●
Black Bittern	Dupetor flavicollis	●	●	●						●	●	●	●
Great Bittern	Botaurus stellaris	●	●	●							●	●	●
Storks	**Ciconiidae**												
Painted Stork	Mycteria leucocephala	●	●	●	●			■	■	■	■	■	●
Asian Openbill	Anastomus oscitans	●	●	●	●	●	●	■	■	■	■	■	●
Woolly -necked Stork	Ciconia episcopus	●	●	●	●	●	●	■	■	■	●	●	●
White Stork	Ciconia ciconia	●	●	●							●	●	●
Black Stork	Ciconia nigra			●	●	●							
Black-necked Stork	Ephippiorhynchus asiaticus	■	●	●	●	●	●	●	■	■	■	■	■
Greater Adjutant	Leptoptilos dubius			●	●	●							
Lesser Adjutant	Leptoptilos javanicus	●	●	●									
Black-headed Ibis	Threskiornis melanocephalus	●	●	●	●	●	●	■	■	■	■	■	●
Black Ibis	Pseudibis papillosa	●	●								●	●	●
Glossy Ibis	Plegadis falcinellus	●	●	●							●	●	●
Eurasian Spoonbill	Platalea leucorodia	●	●	●	●	●	●	●	■	■	■	●	●
Flamingos	**Phoenicopteridae**												
Greater Flamingo	Phoenicopterus ruber	●	●	●								●	●
Lesser Flamingo	Phoenicopterus minor	●	●	●								●	●
Geese, Ducks	**Anatidae**												
Greylag Goose	Anser anser	●	●	●	●						●	●	●
Greater Whitefronted Goose	Anser albifrons	●	●	●							●	●	●
Bar-headed Goose	Anser indicus	●	●	●	●					●	●	●	●
Ruddy Shelduck	Tadorna ferruginea	●	●	●	●					●	●	●	●
Common Shelduck	Tadorna tadorna	●	●	●							●	●	●

CHECKLIST OF BIRDS OF BHARATPUR

COMMON NAME	SCIENTIFIC NAME	JAN	FEB	MAR	APR	MAY	JUN	JUL	AUG	SEP	OCT	NOV	DEC
Lesser Whistling Teal	Dendrocygna javanica	●	●	●	●	●	■	■	■	■	●	●	●
Marbled Teal	Marmaronetta angustirostris	●	●	●								●	●
Northern Pintail	Anas acuta	●	●	●	●							●	●
Common Teal	Anas crecca	●	●	●						●	●	●	●
Baikal Teal	Anas formosa	●	●	●								●	●
Spotbilled Duck	Anas poecilorhyncha	●	●	●	●	●	■	■	■	■	■	●	●
Mallard	Anas platyrhynchos	●	●	●								●	●
Gadwall	Anas strepera	●	●	●								●	●
Falcated Teal	Anas falcata	●	●	●								●	●
Eurasin Wigeon	Anas penelope	●	●	●							●	●	●
Garganey	Anas querquedela	●	●	●	●						●	●	●
Northern Shoveler	Anas clypeata	●	●	●	●						●	●	●
Red-crested Pochard	Rhodonessa rufina	●	●	●								●	●
Common Pochard	Aythya ferina	●	●	●								●	●
Ferruginous Pochard	Aythya nyroca	●	●	●							●	●	●
Tufted Duck	Aythya fuligula	●	●									●	●
Comb Duck	Sarkidiornis melanotos	●	●	●	●	●	●	■	■	■	■	●	●
Cotton Pygmy Goose	Nettapus coromandelianus	●	●	●	●	●	●	■	■	■	■	●	●
Birds of Prey, Vultures	**Accipitridae**												
Black-shoulder Kite	Elanus caeruleus	●	●	●	■	■	■	●	●	●	●	●	●
Oriental Honey Buzzard	Pernis ptilorhynchus	●	●	●	■	●	●	●	●	●	●	●	●
Red Kite	Milvus milvus	●	●									●	●
Black Kite	Milvus migrans	■	■	■	■	●	●	●	●	●	●	●	●
Black-eared Kite	Milvus lineatus	●	●									●	●
Brahminy Kite	Haliastur indus	●	●	●								●	●
Northern Goshawk	Accipiter gentilis	●	●	●							●	●	●
Shikra	Accipiter badius	●	●	■	■	■	■	■	●	●	●	●	●
Eurasian Sparrowhawk	Accipiter nisus	●	●	●	●						●	●	●
Besra	Accipiter virgatus	●	●	●							●	●	●
Long-legged Buzzard	Buteo rufinus	●	●	●							●	●	●
Common Buzzard	Buteo buteo	●	●	●							●	●	●
White-eyed Buzzard	Butaster teesa	●	●	●							●	●	●
Bonelli's Eagle	Hieraaetus fasciatus	●	●	●							●	●	●
Booted Eagle	Hieraaetus pennatus	●	●	●							●	●	●
Golden Eagle	Aquila chrysaetos	●											●
Imperial Eagle	Aquila haliaca	●	●	●							●	●	●
Tawny Eagle	Aquila rapax	●	●	●							●	●	●
Steppe Eagle	Aquila nipalensis	●	●	●							●	●	●
Greater Spotted Eagle	Aquila clanga	●	●	●							●	●	●
Lesser Spotted Eagle	Aquila pomarina	●	●	●	■	■	■	■	●	●	●	●	●
Whitetailed Eagle	Haliaeetus albicilla	●	●									●	●
Pallas's Fish Eagle	Haliaeetus leucoryphus	■	■	●						●	■	■	■
Red headed Vulture	Sarcogyps calvus	●	●	■	■	■	■	●	●	●	●	●	●
Cinereous Vulture	Aegypius monachus	●	●	●								●	●
Long-billed Vulture	Gyps indicus	■	■	■	■	●	●	●	●	●	●	●	■
White-rumped Vulture	Gyps bengalensis	■	■	■	■	●	●	●	●	●	●	●	■
Egyptian Vulture	Neophron percnopterus	●	●	■	■	●	●	●	●	●	●	●	●
Hen Harrier	Circus cyaneus	●	●	●	●						●	●	●
Pallid Harrier	Circus macrourus	●	●	●	●						●	●	●

CHECKLIST OF BIRDS OF BHARATPUR

COMMON NAME	SCIENTIFIC NAME	JAN	FEB	MAR	APR	MAY	JUN	JUL	AUG	SEP	OCT	NOV	DEC
Montagu's Harrier	Circus pygargus	●	●	●	●					●	●	●	●
Pied Harrier	Circus melanoleucos	●	●	●	●					●	●	●	●
Eurasian Marsh harrier	Circus aeruginosus	●	●	●	●					●	●	●	●
Short-toed Snake Eagle	Circaetus gallicus	●	●	■	■	■	■	●	●	●	●	●	●
Crested Serpent Eagle	Spilornis cheela	●	●	●	●					●	●	●	●
Osprey	Pandion haliaetus	●	●	●							●	●	●
Falcons	**Falconidae**												
Saker Falcon	Falco cherrug	●	●	●						●	●	●	●
Laggar Falcon	Falco jugger	●	●	●						●	●	●	●
Peregrine Falcon	Falco peregrinus	●	●	●						●	●	●	●
Eurasian Hobby	Falco subbuteo	●	●	●						●	●	●	●
Oriental Hobby	Falco severus	●	●	●						●	●	●	●
Partridges, Quailes, Peafowls	**Phasianidae**												
Black Francolin	Francolinus francolinus	●	●	●	●	■	■	■	■	●	●	●	●
Grey Francolin	Francolinus pondicerianus	●	●	■	■	■	■	■	■	●	●	●	●
Common Quail	Coturnix coturnix	●	●	●	●	■	■	■	■	●	●	●	●
Jungle Bush Quail	Perdicula asiatica	●	●	●	●	■	■	■	■	●	●	●	●
Rock Bush Quail	Perdicula argoondah	●	●	●	●	■	■	■	■	●	●	●	●
Indian Peafowl	Pavo cristatus	●	●	●	●	●	●	■	■	■	■	●	●
Bustard-Quails	**Turnicidae**												
Barred Butttonquail	Turnix suscitator	●	●	●	●	■	■	■	■	●	●	●	●
Cranes	**Gruidae**												
Common Crane	Grus grus	●	●	●							●	●	●
Sarus Crane	Grus antigone	●	■	■	■	●	●	■	■	■	■	●	●
Siberian Crane	Grus leucogeranus	●	●	●							●	●	●
Demoiselle Crane	Grus virgo	●	●	●							●	●	●
Rails, Crakes, Coots	**Rallidae**												
Water Rail	Rallus aquaticus	●	●	●						●	●	●	●
Spotted Crake	Porzana pozana	●	●								●	●	●
Baillon's Crake	Porzana pusilla	●	●	●							●	●	●
Ruddy breasted Crake	Porzana fusca	●	●	●							●	●	●
Brown Crake	Amaurornis akool	●	●	●	●	●					●	●	●
Whitebreasted Waterhen	Amaurornis phoenicurus	●	●	■	■	■	●	■	■	●	●	●	●
Watercock	Gallicrex cinerea	●	●	●	●	●	●	■	■	●	●	●	●
Common Moorhen	Gallinula chloropus	●	●	●	●	●	●	■	■	●	●	●	●
Purple Moorhen	Porphyrio porphyrio	●	●	●	●	●	●	■	■	●	●	●	●
Coot	Fulica atra	●	●	●	●						●	●	●
Jacanas	**Jacanidae**												
Pheasant-tailed Jacana	Hydrophasianus chirurgus	●	●	■	■	■	●	■	■	■	●	●	●
Bronzewinged Jacana	Metopidius indicus	●	●	■	■	■	●	■	■	■	●	●	●
Snipe	**Rostratulidae**												
Greater Painted Snipe	Roastratula benghalensis	●	●	●	■	■	■	●		●	●	●	●
Plovers, Stilts, Avocets	**Charadriidae**												
Whitetailed Lapwing	Vanellus leucurus	●	●	●							●	●	●
Sociable Lapwing	Vanellus gregarius	●	●	●							●	●	●
Northern Lapwing,	Vanellus vanellus	●	●	●							●	●	●
Greyheaded Lapwing	Vanellus cinereus	●	●	●							●	●	●
Red-wattled Lapwing	Vanellus indicus	●	●	■	■	■	■	■	●	●	●	●	●

CHECKLIST OF BIRDS OF BHARATPUR

COMMON NAME	SCIENTIFIC NAME	JAN	FEB	MAR	APR	MAY	JUN	JUL	AUG	SEP	OCT	NOV	DEC
Yellow-wattled Lapwing	Vanellus malabaricus	●	●	■	■	■	■	■	●	●	●	●	●
River Lapwing	Vanellus duvaucelii	●	●	●							●	●	●
Grey Plover	Pluvialis squatarola	●	●	●							●	●	●
Pacific Golden Plover	Pluvialis fulva	●	●	●							●	●	●
Common Ringed Plover	Charadrius hiaticula	●	●	●							●	●	●
Little Ringed Plover	Charadrius dubius	●	●	●	●						●	●	●
Kentish Plover	Charadrius alexandrinus	●	●	●							●	●	●
Lesser Sand Plover	Charadrius mongolus	●	●	●	●						●	●	●
Black-winged Stilt	Himantopus himantopus	●	●	●	●			●	●	●	●	●	●
Pied Avocet	Recurvirostra avosetta	●	●	●						●	●	●	●
Sandpipers	**Scolopacidae**												
Eurasian Curlew	Numenius arquata	●	●	●						●	●	●	●
Black-tailed Godwit	Limosa limosa	●	●	●	●					●	●	●	●
Spotted Redshank	Tringa erythropus	●	●	●						●	●	●	●
Common Redshank	Tringa totanus	●	●	●						●	●	●	●
Marsh Sandpiper	Tringa stagnatilis	●	●	●	●					●	●	●	●
Common Greenshank	Tringa nebularia	●	●	●	●					●	●	●	●
Green Sandpiper	Tringa ochropus	●	●	●	●					●	●	●	●
Wood Sandpiper	Tringa glareola	●	●	●						●	●	●	●
Common Sandpiper	Actitis hypoleucos	●	●	●						●	●	●	●
Terek Sandpiper	Xenus cinereus	●	●	●	●						●	●	●
Ruddy Turnstone	Arenaria interpres	●	●	●							●	●	●
Pintail Snipe	Gallinago stenura	●	●	●	●					●	●	●	●
Common Snipe	Gallinago gallinago	●	●	●	●					●	●	●	●
Jack Snipe	Lymnocryptes minimus	●	●	●	●					●	●	●	●
Red Knot	Calidris canutus	●	●	●						●	●	●	●
Little Stint	Calidris minuta	●	●	●						●	●	●	●
Temminck's Stint	Calidris temminckii	●	●	●						●	●	●	●
Dunlin	Calidris alpina	●	●	●	●					●	●	●	●
Curlew Sandpiper	Calidris ferruginea	●	●	●							●	●	●
Broad-billed Sandpiper	Limicola falcinellus	●	●	●							●	●	●
Ruff	Philomachus pugnax	●	●	●	●					●	●	●	●
Red-necked Phalarope	Phalaropus lobatus	●	●	●							●	●	●
Thick-Knees	**Burhinidae**												
Eurasian Thick-knee	Burhinus oedicnemus	●	●	●	■	■	■	■	●	●	●	●	●
Coursers, Pratincoles	**Glareolidae**												
Indian Courser	Cursorius coromandelicus	●	●	●	●	■	■	■	■	●	●	●	●
Collared Pratincole	Glareola pratincola	●	●	●	●	●				●	●	●	●
Small Pratincole	Glareola lactea	●	●								●	●	●
Gulls, Terns	**Laridae**												
Yellowlegged Gull	Larus cachinnans	●	●	●								●	●
Black-headed Gull	Larus ichthyaetus	●	●	●								●	●
Brown-headed Gull	Larus brunnicephalus	●	●	●								●	●
Whiskered Tern	Chlidonias hybridus	●	●	●							●	●	●
Black Tern	Chlidonias niger	●	●	●							●	●	●
Gull-billed Tern	Gelochelidon nilotica	●	●	●							●	●	●
Caspian Tern	Strena caspia												
River Tern	Sterna aurantia	●	●									●	●
Common Tern	Sterna hirundo	●	●									●	●

CHECKLIST OF BIRDS OF BHARATPUR

COMMON NAME	SCIENTIFIC NAME	JAN	FEB	MAR	APR	MAY	JUN	JUL	AUG	SEP	OCT	NOV	DEC
Black-bellied Tern	Sterna acuticauda	●	●	●						●	●	●	●
Little Tern	Sterna albifrons	●	●	●						●	●	●	●
Indian Skimmer	Rynchops albicollis	●	●									●	●
Sandgrouse	**Pteroclidae**												
Chestnutbellied Sandgrouse	Pterocles exustus	●	●	■	■	■	■	●	●	●	●	●	●
Pigeons, Doves	**Columbidae**												
Yellowfooted Green Pigeon	Treron phoenicoptera	●	●	●	■	■	■	●	●	●	●	●	●
Rock Pigeon	Columba livia	●	●	■	■	■	■	■	■	●	●	●	●
Yellow-eyed Pigeon	Columba eversmanni	●	●									●	●
Oriental Turtle Dove	Streptopelia orientalis	●	●	■	■	■	■	■	■	■	●	●	●
Eurasian Collared Dove	Streptopelia decaocto	●	●	■	■	■	■	■	■	●	●	●	●
Red Collared Dove	Streptopelia tranquebarica	●	●	■	■	■	■	■	■	●	●	●	●
Spotted Dove	Streptopelia chinensis	●	●	■	■	■	■	■	■	●	●	●	●
Laughing Dove	Streptopelia senegalensis	●	●	■	■	■	■	■	■	●	●	●	●
Parakeets	**Psittacidae**												
Rose-ringed Parakeet	Psittacula krameri	●	■	■	■	■	■	■	●	●	●	●	●
Plum-headed Parakeet	Psittacula cyanocephala	●	●	●						●	●	●	●
Cuckoos	**Cuculidae**												
Pied Cuckoo	Clamator jacobinus						■	■	■	■	■		
Common Hawk-Cuckoo	Hierococcyx varius						■	■	■	■	■		
Eurasian Cuckoo	Cuculus canorus						■	■	■	■			
Greybellied Cuckoo	Cacomantis passerinus						■	■	■				
Asian Koel	Eudynamys scolopacea	●	●	●	●	■	■	■	■	■	●	●	●
Sirkeer Malkoha	Phaenicophaeus leschenaultii	●	●	●	●	■	■	■	■	■	●	●	●
Coucals	**Centropodidae**												
Greater Coucal	Centropus sinensis	●	●	■	■	■	■	■	●	●	●	●	●
Owls	**Strigidae**												
Barn Owl	Tyto alba	●	■	■	■		■	●	●	●	●	●	●
Eurasian Scops Owl	Otus scops	●	●	●	●					●	●	●	●
Collared Scops Owl	Otus bakkamoena	●	■	■	■	■	■	■	●	●	●	●	●
Eurasian Eagle-Owl	Bubo bubo	●	●	●	●	●	●	●	●	●	●	●	●
Dusky Eagle-Owl	Bubo coromandus	■	■	●	●	●	●	●	●	●	■	■	■
Brown Fish Owl	Ketupa zeylonensis	●	●	●	●	●	●	●	●	●	●	●	●
Brown Hawk Owl	Ninox scutulata	●	●	●									
Spotted Owlet	Athene brama	●	●	■	■	■	■	■	■	●	●	●	●
Mottled Wood Owl	Strix ocellata	●	●	■	■	■	■	■	●	●	●	●	●
Short-eared Owl	Asio flammeus	●	●								●	●	●
Nightjars	**Caprimulgidae**												
Grey Nightjar	Caprimulgus indicus	●	●	■	■	■	■	●	●	●	●	●	●
Syke's Nightjar	Caprimulgus mahrattensis			■	■	■	■						
Indian Nightjar	Caprimulgus asiaticus	●	●	■	■	■	■	●	●	●	●	●	●
Savanna Nightjar	Caprimulgus affinis	●	●	■	■	■	■	■	●	●	●	●	●
Swifts	**Apodidae**												
Alpine Swift	Tachymarptis melba	●	●	●						●	●	●	●
House Swift	Apus affinis	●	■	■	■	■	■	●	●	●	●	●	●
Asian Palm Swift	Cypsiurus balasiensis	●	■	■	■	■	■	●	●	●	●	●	●
Kingfishers	**Alcedinidae**												
Pied Kingfisher	Ceryle rudis	●	●	■	■	■	■	■	●	●	●	●	●
Common Kingfisher	Alcedo atthis	●	●	■	■	■	■	■	●	●	●	●	●

CHECKLIST OF BIRDS OF BHARATPUR

COMMON NAME	SCIENTIFIC NAME	JAN	FEB	MAR	APR	MAY	JUN	JUL	AUG	SEP	OCT	NOV	DEC
Stork-billed Kingfisher	Halcyon capensis	●	●	●							●	●	●
White-throated Kingfisher	Halcyon smyrnensis	●	■	■	■	■	■	■	●	●	●	●	●
Black Capped Kingfisher	Halcyon pileata	●	●	●								●	●
Bee-eaters	**Meropidae**												
Blue-cheeked Bee-eater	Merops persicus			■	■	■	■						
Blue-tailed Bee-eater	Merops philippinus	●	●	■	■	■	■	■	●	●	●	●	●
Green Bee-eater	Merops orientalis	●	●	■	■	■	■	■	●	●	●	●	●
Rollers	**Coraciidae**												
European Roller	Coracias garrulus	●	●	●							●	●	●
Indian Roller	Coracias benghalensis	●	●	■	■	■	■	■	■	●	●	●	●
Hoopoes	**Upupidae**												
Common Hoopoe	Upupa epops	●	■	■	■	■	■	■	●	●	●	●	●
Hornbills	**Bucerotidae**												
Indian Grey Hornbill	Ocyceros birostris	●	●	■	■	■	■	■	■	●	●	●	●
Asian Barbets	**Megalaimidae**												
Brown-headed Barbet	Megalaima zeylanica	●	●	■	■	■	■	■	●	●	●	●	●
Coppersmith Barbet	Megalaima haemacephala	●	●	■	■	■	■	■	●	●	●	●	●
Wryneck, Woodpecker	**Picidae**												
Eurasian Wryneck	Jynx torquilla	●	●	●							●	●	●
Black-rumped Flameback	Dinopium benghalense	●	■	■	■	■	■	■	■	●	●	●	●
Yellowcrowned Woodpecker	Dendrocopos maharattensis	●	■	■	■	■	■	■	■	●	●	●	●
Brown-capped Pigmy Woodpecker	Dendrocopos nanus	●	■	■	■	■	■	■	■	●	●	●	●
Pittas	**Pittidae**												
Indian Pitta	Pitta brachyura				■	■	■	■	■				
Larks	**Alaudidae**												
Indian Bushlark	Mirafra erythroptera	●	●	■	■	■	■	■	●	●	●	●	●
Ashy-crowned Sparrow Lark	Eremopterix grisea	●	●	■	■	■	■	■	●	●	●	●	●
Rufous-tailed Lark	Ammomanes phoenicurus	●	●	■	■	■	■	■	●	●	●	●	●
Greater Short-toed Lark	Calandrella brachydactyla	●	●	●							●	●	●
Sand Lark	Calandrella raytal	●	●	■	■	■	■	■	●	●	●	●	●
Crested Lark	Galerida cristata	●	●	■	■	■	■	■	●	●	●	●	●
Syke's Crested Lark	Galerida deva	●	●	■	■	■	■	■	●	●	●	●	●
Eurasian Skylark	Alauda arvensis	●	●	■	■	■	■	■	●	●	●	●	●
Oriental Skylark	Alauda gulgula	●	●	■	■	■	■	■	●	●	●	●	●
Martins, Swallows	**Hirundinidae**												
Sand Martin	Riparia riparia	●	●	●							●	●	●
Plain Martin	Riparia paludicola	●	■	■	■	■	■	■	●	●	●	●	●
Dusky Crag Martin	Hirundo concolor	●	■	■	■	■	■	■	●	●	●	●	●
Barn Swallow	Hirundo rustica	●	●	●							●	●	●
Wire-tailed Swallow	Hirundo smithii	●	●	●							●	●	●
Streakthroated Swallow	Hirundo fluvicola	●	●	●							●	●	●
Red-rumped Swallow	Hirundo daurica	●	●	●							●	●	●
Shrikes	**Laniidae**												
Great Grey Shrike	Lanius excubitor	●	●	■	■	■	■	■	●	●	●	●	●
Bay-backed Shrike	Lanius vittatus	●	●	●	■	■	■	■	●	●	●	●	●
Red-backed Shrike	Lanius collurio	●	●	●							●	●	●
Long-tailed Shrike	Lanius schach	●	●	■	■	■	■	■	■	●	●	●	●
Brown Shrike	Lanius cristatus	●	●	●							●	●	●

CHECKLIST OF BIRDS OF BHARATPUR

COMMON NAME	SCIENTIFIC NAME	JAN	FEB	MAR	APR	MAY	JUN	JUL	AUG	SEP	OCT	NOV	DEC
Grey-backed Shrike	Lanius tephronotus	●	●	●							●	●	●
Orioles, Drongos, Tree Pies, Crows, Cuckoo-shrikes, Minivets, Ioras	**Corvidae**												
Eurasian Golden Orioles	Oriolus oriolus	●	●	●	●	■	■	■	■	●	●	●	●
Black-hooded Oriole	Oriolus xanthornus	●	●	●							●	●	●
Black Drongo	Dicrurus macrocercus	●	●	●	●	■	■	■	■	●	●	●	●
White-bellied Drongo	Dicrurus caerulescens	●	●	●	●	■	■	■	■	●	●	●	●
Spangled Drongo	Dicrurus hottentotus	●	●	●	●	■	■	■	■	●	●	●	●
Ashy Drongo	Dicrurus leucophaeus	●	●	●							●	●	●
Rufous Tree Pie	Dendrocitta vagabunda	●	●	●	●	■	■	■	■	●	●	●	●
House Crow	Corvus splendens	●	●	●	●	■	■	■	■	●	●	●	●
Large-billed Crow	Corvus macrorhynchus	●	●	●	●	■	■	■	■	●	●	●	●
Common Wood Shrike	Tephrodornis pondicerianus	●	●	■	■	■	■	■	■	●	●	●	●
Black-headed Cuckoo-Shrike	Coracina melanoptera				●	●	●	●	●				
Large Cuckoo-Shrike	Coracina novaehollantiae	●	●	●	●	■	■	■	■	●	●	●	●
Scarlet Minivet	Pericrocotus flammeus					■	■	■	■				
Short-billed Minivet	Pericrocotus brevirostris					■	■	■	■				
Small Minivet	Pericrocotus cinnamomeus	●	●	●	●	■	■	■	■	●	●	●	●
White-bellied Minivet	Pericrocotus erythropygius	●	●	●	●	■	■	■	■	●	●	●	●
Common Iora	Aegithina tiphia	●	●	●	●	■	■	■	■	●	●	●	●
Marshall's Iora	Aegithina nigrolutea	●	●	●	●	■	■	■	■	●	●	●	●
Mynas, Starlings	**Sturnidae**												
Brahminy Starling	Sturnus pagodarum	●	●	●	■	■	■	■	■	●	●	●	●
Rosy Starling	Sturnus roseus	●	●	●	●					●	●	●	●
Common Starling	Sturnus vulgaris	●	●	●	●					●	●	●	●
Asian Pied Myna	Sturnus contra	●	●	●	●	■	■	■	■	●	●	●	●
Common Myna	Acridotheres tristis	●	●	●	●	■	■	■	■	●	●	●	●
Bank Myna	Acridotheres ginginianus	●	●	●	●	■	■	■	■	●	●	●	●
Bulbuls	**Pycnonotidae**												
Red-whiskered Bulbul	Pycnonotus jocosus	●	●	●	●	■	■	■	■	●	●	●	●
White-eared Bulbul	Pycnonotus leucotis	●	●	●	●	■	■	■	■	●	●	●	●
Red-vented Bulbul	Pycnonotus cafer	●	●	●	●	■	■	■	■	●	●	●	●
White-browed Bulbul	Pycnonotus luteolus	●	●	●							●	●	●
Babblers, Warblers	**Silvidae**												
Yellow-eyed Babbler	Chrysomma sinense	●	●	●	●	■	■	■	■	●	●	●	●
Common Babbler	Turdoides caudatus	●	●	●	●	■	■	■	■	●	●	●	●
Large Grey Babbler	Turdoides malcolmi	●	●	●	●	■	■	■	■	●	●	●	●
Jungle Babbler	Turdoides striatus	●	●	●	●	■	■	■	■	●	●	●	●
Cetti's Warbler	Cettia cetti	●	●								●	●	●
Zitting Cisticola	Cisticola juncidis	●	●	●	●	■	■	■	■	●	●	●	●
White-browed Fantail	Rhipidura aureola	●	●	●	●	■	■	■	■	●	●	●	●
Rufous-fronted Prinia	Prinia buchanani	●	●	●	●	■	■	■	■	●	●	●	●
Plain Prinia	Prinia inornata	●	●	●	●	■	■	■	■	●	●	●	●
Ashy Prinia	Prinia socialis	●	●	●	●	■	■	■	■	●	●	●	●
Common Tailorbird	Orthotomus sutorius	●	●	●	●	■	■	■	■	●	●	●	●
Lanceolated Warbler	Locustella lanceolata	●	●	●							●	●	●
Thick-billed Warbler	Acrocephalus aedon	●	●	●							●	●	●

CHECKLIST OF BIRDS OF BHARATPUR

COMMON NAME	SCIENTIFIC NAME	JAN	FEB	MAR	APR	MAY	JUN	JUL	AUG	SEP	OCT	NOV	DEC
Clamorous Reed Warbler	Acrocephalus stentoreus	●	●	●	●	■	■	■	■	■	●	●	●
Blyth's Reed Warbler	Acrocephalus dumetorum	●	●	●						●	●	●	●
Blunt-winged Warbler	Acrocephalus concinens	●	●	●							●	●	●
Paddyfield Warbler	Acrocephalus agricola	●	●	●							●	●	●
Booted Warbler	Hippolais caligata	●	●	●							●	●	●
Orphean Warbler	Sylvia hortensis	●	●	●							●	●	●
Greater Whitethroat	Sylvia communis	●	●	●							●	●	●
Lesser Whitethroat	Sylvia curruca	●	●	●							●	●	●
Hume's Whitethroat	Sylvia corruca althaea	●	●	●							●	●	●
Desert Warbler	Sylvia nana	●	●	●							●	●	●
Common Chiffchaff	Phylloscopus collybita	●	●	●							●	●	●
Tytler's Leaf Warbler	Phylloscopus tytleri	●	●	●							●	●	●
Tickell's Leaf Warbler	Phylloscopus affinis	●	●	●							●	●	●
Sulphurbellied Warbler	Phylloscopus griseolus	●	●	●							●	●	●
Dusky Warbler	Phylloscopus fuscatus	●	●	●							●	●	●
Yellow-browed Warbler	Phylloscopus inornatus	●	●	●							●	●	●
Brook's Leaf Warbler	Phylloscopus subviridis	●	●	●							●	●	●
Lemon-rumped Warbler	Phylloscopus proregulus	●	●	●							●	●	●
Greenish Warbler	Phylloscopus trochiloides	●	●	●							●	●	●
Western Crowned Warbler	Phylloscopus occipitalis	●	●	●							●	●	●
Robins, Chats, Thrushes, Flycatchers	**Muscicapidae**												
Siberian Rubythroat	Luscinia calliope	●	●	●							●	●	●
White-tailed Rubythroat	Luscinia pectoralis	●	●	●							●	●	●
Bluethroat	Luscinia svecica	●	●	●							●	●	●
Indian Robin	Saxicoloides fulicata	●	●	●	■	■	■	■	■	■	●	●	●
Oriental Magpie Robin	Copcychus saularis	●	●	●	■	■	■	■	■	■	●	●	●
Black Redstart	Phoenicurus ochruros	●	●	●	●					●	●	●	●
Indian Chat	Cercomela fusca	●	●	●	●	■	■	■	■	●	●	●	●
Common Stone Chat	Saxicola torquata	●	●	●							●	●	●
Grey Bushchat	Saxicoa ferrea	●	●	●							●	●	●
Pied Bushchat	Saxicola caprata	●	●	●	■	■	■	■	■	●	●	●	●
Variable Wheatear	Oenanthe picata	●	●	●							●	●	●
Desert Wheatear	Oenanthe deserti	●	●	●							●	●	●
Blue-capped Rock Thrush	Monticola cinclorhynchus	●	●	●							●	●	●
Blue Rock Thrush	Monticola solitarius	●	●	●							●	●	●
Orangeheaded Thrush	Zoothera citrina	●	●	●							●	●	●
Tickell's Thrush	Turdus unicolor	●	●	●							●	●	●
Red-throated Thrush	Turdus ruficollis	●	●	●							●	●	●
Grey-winged Blackbird	Turdus boulboul	●	●	●							●	●	●
Grey-winged Blackbird	Turdus boulboul	●	●	●							●	●	●
Red-throated Flycatcher	Ficedula parva	●	●	●							●	●	●
Ultramarine Flycatcher	Ficedula superciliaris	●	●	●							●	●	●
Rusty-tailed Flycatcher	Cyornis ruficauda	●	●	●	●	■	■	■	■	●	●	●	●
Tickell's Blue Flycatcher	Cyornis tickelliae	●	●	●							●	●	●
Verditer Flycatcher	Eumyias thalassina	●	●	●							●	●	●
Grey-headed Canary Flycatcher	Culicicapa ceylonensis	●	●	●	●	■	■	■	■	●	●	●	●
White-browed Fantail	Rhipidura aureola	●	●	●	●	■	■	■	■	●	●	●	●
Asian Paradise Flycatcher	Terpsiphone paradisi	●	●	●	●	■	■	■	■	●	●	●	●

CHECKLIST OF BIRDS OF BHARATPUR

COMMON NAME	SCIENTIFIC NAME	JAN	FEB	MAR	APR	MAY	JUN	JUL	AUG	SEP	OCT	NOV	DEC
Tits	**Paridae**												
Great Tit	Parus major	●	●	●	●	■	■	■	■	●	●	●	●
Nuthatches	**Sittidae**												
Chestnut-bellied Nuthatch	Sitta castanea	●	●	●	●	■	■	■	■	●	●	●	●
Treecreepers	**Certhiidae**												
Spotted Creeper	Salpornis spilonotus	●	●	●	●	■	■	■	■	●	●	●	●
Pipits, Wagtails, Waxbills, Sparrows, Weavers	**Passeridae**	●	●	●							●	●	●
Olive-backed Pipit	Anthus hodgsoni	●	●	●							●	●	●
Tree Pipit	Anthus trivialis	●	●	●	●	■	■	■	■	●	●	●	●
Paddyfield Pipit	Anthus rufulus	●	●	●							●	●	●
Tawny Pipit	Anthus campestris	●	●	●							●	●	●
Blyth's Pipit	Anthus godlewskii	●	●	●							●	●	●
Rosy Pipit	Anthus roseatus	●	●	●							●	●	●
Water Pipit	Anthus spinoletta	●	●	●							●	●	●
Forest Wagtail	Dendronanthus indicus	●	●	●							●	●	●
Yellow Wagtail	Motacilla flava	●	●	●							●	●	●
Citrine Wagtail	Motacilla citreola	●	●	●							●	●	●
Grey Wagtail	Motacilla cinerea	●	●	●							●	●	●
White Wagtail	Motacilla alba	●	●	●							●	●	●
Whitebrowed Wagtail	Motacilla maderaspatensis	●	●	●	■	■	■	■	■	●	●	●	●
Red Avadavat	Amandava amandava	●	●	●	■	■	■	■	■	■	●	●	●
Indian Silverbill	Lonchura malabarica	●	●	●	■	■	■	■	■	■	●	●	●
White-rumped Munia	Lonchura striata	●	●	●	■	■	■	■	■	■	●	●	●
Scaly-breasted Munia	Lonchura punctulata	●	●	●	■	■	■	■	■	■	●	●	●
Black-headed Munia	Lonchura malacca	●	●	●	■	■	■	■	■	■	●	●	●
House Sparrow	Passer domesticus	●	●	●	■	■	■	■	■	■	●	●	●
Spanish Sparrow	Passer hispaniolensis	●	●	●	●					●	●	●	●
Chestnut-shouldered Petronia	Petronia xanthocollis	●	●	●	■	■	■	■	■	■	●	●	●
Baya Weaver	Ploceus philippinus	●	●	●	■	■	■	■	■	■	●	●	●
Black-breasted Weaver	Ploceus benghalensis	●	●	●	■	■	■	■	■	■	●	●	●
Streaked Weaver	Ploceus manyar	●	●	●	■	■	■	■	■	■	●	●	●
Flowerpeckers, Sunbirds	**Nectariniidae**												
Thick-billed Flowerpecker	Dicaeum agile	●	●	●	●	■	■	■	■	●	●	●	●
Pale-billed Flowerpecker	Dicaeum erythrorhynchos	●	●	●	●	■	■	■	■	●	●	●	●
Purple Sunbird	Nectarinia asiatica	●	●	●	■	■	■	■	■	■	●	●	●
White-eyes	**Zosteropidae**												
Oriental White-eye	Zosterops palpebrosus	●	●	●	■	■	■	■	■	■	●	●	●
Finches, Buntings	**Fringillidae**												
Common Rosefinch	Carpodacus erythrinus	●	●	●							●	●	●
Black-headed Bunting	Emberiza melanocephala	●	●	●						●	●	●	●
Red-headed Bunting	Emberiza bruniceps	●	●	●							●	●	●
White-capped Bunting	Emberiza stewarti	●	●	●							●	●	●
Chestnut-eared Bunting	Emberiza fucata	●	●	●							●	●	●
Crested Bunting	Melophus lathami	●	●	●	■	■	■	■	■	■	●	●	●